THE VISUAL ELEMENTS—PHOTOGRAPHY

The Visual Elements
Photography

A Handbook for Communicating Science and Engineering

FELICE C. FRANKEL

The University of Chicago Press
Chicago and London

The University of Chicago Press, Chicago 60637
The University of Chicago Press, Ltd., London
© 2023 by Felice C. Frankel
All rights reserved. No part of this book may be used or reproduced in any manner whatsoever without written permission, except in the case of brief quotations in critical articles and reviews. For more information, contact the University of Chicago Press, 1427 E. 60th St., Chicago, IL 60637.
Published 2023
Printed in China

32 31 30 29 28 27 26 25 24 23 1 2 3 4 5

ISBN-13: 978-0-226-82702-5 (paper)
ISBN-13: 978-0-226-82703-2 (e-book)
DOI: https://doi.org/10.7208/chicago/9780226827032.001.0001

Image credits: 4.34a and 4.34b: Photo by Andrew Posselt; 5.8c: iStock.com/channarongsds; 6.2: NASA, ESA, CSA, and STScI; 6.15a and 6.15b: Photos by Derya Akkaynak. Captured in Papua New Guinea and created using Sea-thru, a technology protected by a registered patent owned by Carmel Ltd., the Economic Co. of the Haifa University and its subsidiary SeaErra; 6.16a and 6.16b: Photos by Tom Shlesinger.

Library of Congress Cataloging-in-Publication Data

Names: Frankel, Felice, author. | Frankel, Felice. Visual elements.
Title: The visual elements—photography : a handbook for communicating science and engineering / Felice C. Frankel.
Description: Chicago ; London : The University of Chicago Press, 2023. | Series: The visual elements
Identifiers: LCCN 2022056830 | ISBN 9780226827025 (paperback) | ISBN 9780226827032 (ebook)
Subjects: LCSH: Photography—Scientific applications—Handbooks, manuals, etc. | Visual communication in science—Handbooks, manuals, etc.
Classification: LCC TR692.5 .F72 2023 | DDC 770—dc23/eng/20221205
LC record available at https://lccn.loc.gov/2022056830

♾ This paper meets the requirements of ANSI/NISO Z39.48-1992 (Permanence of Paper).

Contents

Introduction vii

1 **SCANNER** 1

2 **PHONE** 35

3 **CAMERA** 71

4 **MICROSCOPE** 131

5 **PUTTING IT TOGETHER** 177

6 **IMAGE INTEGRITY** 201

Submitting for Publication 223

Gratitude 225

Introduction

In 1998, I wrote in an article in *Science*:

I believe that we who are privileged to see science's splendor, who image it, diagram it, model it, graph it, and compose its data, can turn the world around, dazzling it with what inspires and nourishes our thinking. But first, we must refine the visual vocabulary we use to communicate our investigations and incorporate—beautifully and above all accurately—the visual component that is already there. Our goal must be to share the visual richness of our world, to make it accessible.

Now, nearly 25 years later, in a time of pandemic and disinformation, the need to share science's splendor with a broad audience is even more critical. The Visual Elements is a series of handbooks intended to inspire you to make your own research accessible. These short books are both primers for readers who are new to visual communication and quick guides for those with more experience. My hope is that these books will encourage you, no matter your experience, to better understand the tools to create your own compelling and communicative visuals.

This first "element" in the series, *Photography*, explains how

to create still photographs using various instruments, whether your phone or a microscope. Creating a stunning, honest, and technically superior still image should always be part of your thinking.

It shouldn't be a surprise that this is a visually driven book, and you may find yourself flipping through the content and considering the photographs alone. That's encouraged! At the same time, I ask you to stop and consider more than the photographs that are most closely related to your own research subject—to concentrate on the images themselves and how they were made. Consider the connection of the photographic process to your own work.

The images you'll see here are mostly mine, created over years of refining my process. You might think that some of the images are impossible for you to re-create, but I am convinced that you can do it. The following overview will give you a sense of what we'll cover.

Chapter 1: Scanner

WHY USE A SCANNER?

- The scanner is a quick, relatively inexpensive, high-quality camera alternative.
- The scanner is very useful for creating images for drafts, as place-holders, and for patent submissions.

CONSIDER

- Is your subject appropriate for a scanner?
- Will the details you want to capture measure somewhere from a few millimeters to a few centimeters in size?
- You might be surprised that many three-dimensional objects work well on a scanner. Why not experiment with them?
- Is the background of your subject distracting?

EXPERIMENT

- Try different positions for objects on the scanner.
- Try transmitted and reflective modes if your sample is translucent.
- Capture a large file so that you can crop and maintain resolution.

CHECK YOUR SETTINGS

- Using more dots per inch provides finer detail.

RECORD

- Keep a record of your process.

Chapter 2: Phone

WHY USE A PHONE CAMERA?

- A phone camera is good for quick portraits, documentation, grant submissions, and correspondence.
- A phone camera is helpful for capturing placeholder images for submissions until you can set up a high-resolution shot.

- A phone camera is handy for spontaneous situations when no other camera is available.
- Don't use a phone camera when you need shots with fine detail or you have plans to enlarge.
- A phone might not be sufficient to capture high-resolution images, particularly for quality print and journal submissions.

CONSIDER

- Remember background, lighting, and composition.
- Remember that a less-than-perfect quick shot can be improved after you've captured it by straightening, cropping, and adjusting brightness.

EXPERIMENT

- Notice the differences in color when taking an image with different lighting.

CHECK YOUR SETTINGS

- Turn off flash—it's often unnecessary and can add an artificial look to your image.

RECORD

- Keep a record of your process.

Chapter 3: Camera

WHY USE A CAMERA?

- A camera is useful when you need a high-resolution image that captures details.
- A camera is great for zooming in on an image and maintaining clarity.
- A camera is good when you need a large file size, such as for a journal cover submission.
- A camera is needed when you want to control depth of field.

CONSIDER
- Understand exposure: ISO, f-stop, and shutter speed. Do not depend on automatic settings.
- Use the right tools: a camera with a large sensor, a tripod, a 105mm lens, and computer software.

EXPERIMENT
- Try various f-stops to determine what you want in focus.
- Use various lighting setups.
- Pay attention to shadows.
- Try different backgrounds.
- Change your point of view.
- Play with composition.

CHECK YOUR SETTINGS
- Make sure your exposure is correct.
- Do not use automatic settings.

RECORD
- Keep a record of your process.

Chapter 4: Microscope

WHY USE A MICROSCOPE?
- A microscope is good when you need to capture details not visible to the eye.

CONSIDER
- Which kind of microscope: optical (e.g., compound, dissecting, phase contrast), scanning electron microscopy, transmission electron microscopy, confocal, and so on?
- Use of the microscope along with a camera to communicate context.
- Use of differential interference contrast, a technique to emphasize surface structure.

- Look in the viewfinder on your camera, or on your computer screen, not through the ocular, to consider what the image looks like.

EXPERIMENT
- If using optical microscopy, compare darkfield and brightfield.
- Try a number of magnifications, not just one.
- Try "stacking" if not everything is in focus.

CHECK YOUR SETTINGS
- Make sure your exposure is correct.

RECORD
- Keep a record of your process.

Chapter 5: Putting It Together

WHY COMBINE IMAGES?
- Combining images allows for the creation of an image of something that is otherwise impossible to capture.
- Combining images creates visual metaphors to explain the science.

CONSIDER
- Think about making images to create a library of pieces that you can later combine with others.
- Think about the metaphors you can create with images that will help communicate your research concepts.

EXPERIMENT
- Try putting pieces of images together digitally and take note of the challenges of doing so.

RECORD
- Keep a record of your process.

Chapter 6: Image Integrity

- Always ask yourself, How far can I go to enhance this image? What are the rules I should follow?
- You must clearly describe what you have done to enhance or alter an image.
- You must not change the data.
- Individual journals and publications all have their own guidelines you will need to follow.
- Figure images are often strictly reviewed by journals with respect to retouching and even removing visual artifacts like cracks and dust.

Note: With a few exceptions (see page iv), all images are my own work. Many of the images in this handbook have been sparingly digitally "cleaned" for clarity.

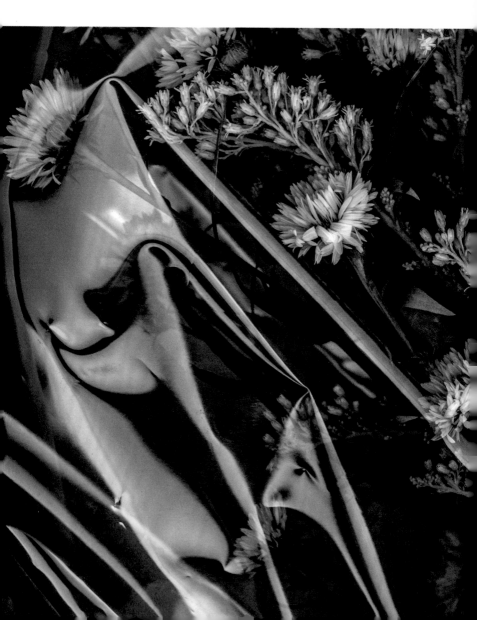

1
Scanner

1.0

Years ago, I started playing with my flatbed scanner. I do mean playing. I was aware of various artists using scanners, but I never thought that by using one I could get the quality required for my professional work. Today the scanner is an important tool in my toolbox. It may be for you, too.

The image that opens this chapter (1.0) is one of the first I made with my scanner—it shows a gift of flowers wrapped in acetate. *Amazing,* I thought. *And ridiculously easy.*

Too easy to be taken seriously? No. The scanner quickly gives us high-quality photographs without the time and effort that lighting setups require. The key to obtaining high quality, though, is to use the correct scanner settings.

Not everything, of course, is scannable. As you experiment, you'll see what I mean, and you'll find some of your own solutions. For example, reflective materials cause difficulties. Sometimes rotating the sample by ninety degrees can help. Other times you might need to try making the object flatter.

Take, for example, a scan I made of physical chemist John A. Rogers's "fliers," miniature electronic devices inspired by seeds that he proposed for environmental monitoring. These fliers measure about 3 millimeters across. In my first scan of these small devices (1.1a), the reflective circuitry created distracting bright spots. When I realized the material was simply not lying flat, I put a few heavy books on the cover of the scanner to flatten the material. This fixed the problem (1.1b).

Sometimes we might need another trick or another tool. Look at the dragonfly wings that my friend Mary discovered on her terrace (1.2a). Unlike the previous fliers, the wings were flat, but the scan failed to capture the interesting reflections and three-dimensional quality my eyes saw when holding up the wings and looking at them. Those characteristics were visible when I took out my phone camera and photographed the wings in daylight coming through my studio window (1.2b). I might prefer the second image.

What's my point? It's a good idea not to get stuck always using the same tool for imaging your work. That's why this book offers several tools. If you can find yet a different point of view by using another instrument, go with it.

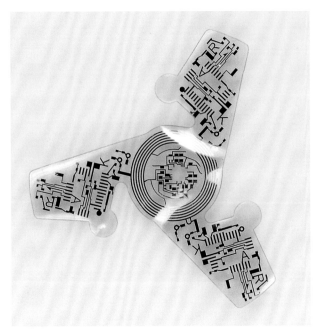

1.1a

1.1b

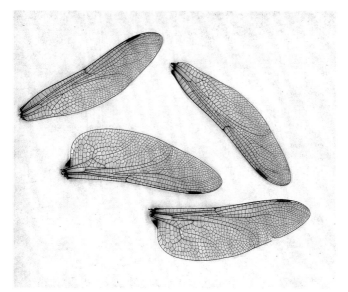

1.2a

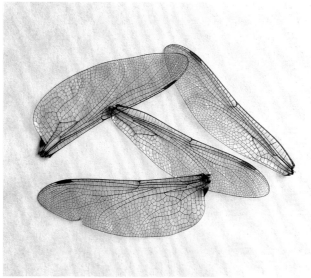

1.2b

Settings

A scanner gives remarkable results if you can capture your image at the right resolution. In a scanner's settings, you should be able to specify a value for dots per inch, or dpi. Generally, the greater the dpi value, the more detail you will capture. Typically, when submitting images for printed publications, you will need to ensure that the images were captured at least at 300 dpi or greater at the size that will be printed. Consider an image that shows scanning a detail of a device related to "e-ink" at various settings (1.3). Notice how the clarity increases as the dpi increases. You might try it yourself and get different results.

Take a look at an image of the silica skeleton of a Euplectella, a sea sponge (1.4a). This one measured about 20 centimeters (8 inches) long. I simply put it on the scanner, covered it with black cloth, and scanned it, resulting in a 180 megabyte (MB) image. The next image is a zoomed-in and cropped detail of the first one that shows silica fibers measuring about 50 micrometers (1.4b). That's pretty remarkable detail. The image almost looks like it was captured under a microscope.

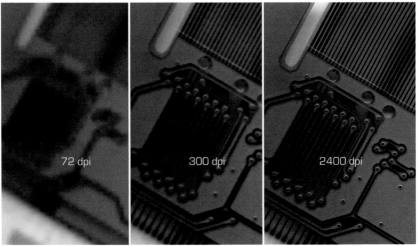

1.3

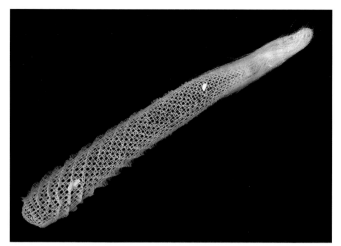

1.4a

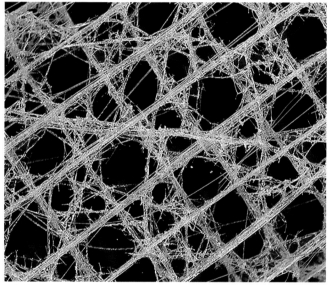

1.4b

Again, scanners can capture incredible detail. Look at the image of a peacock feather, a zoomed-in detail from a larger image originally captured to give a 150 MB image (1.5).

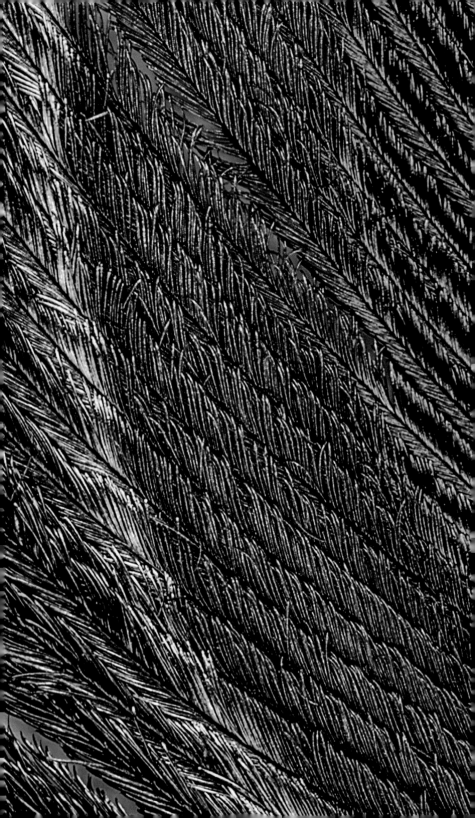

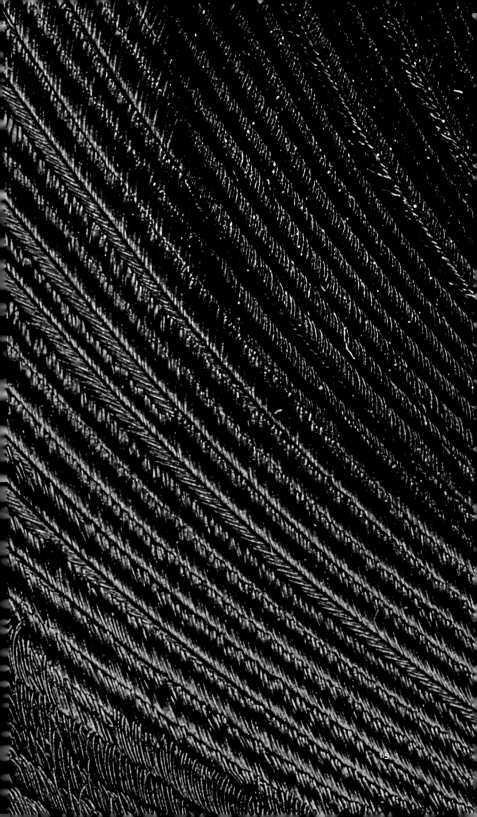

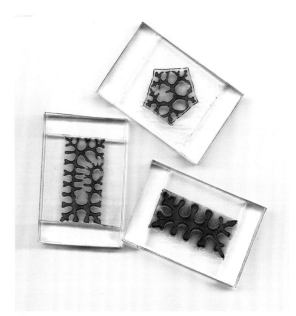

1.6a

1.6b

Reflective and Transparent Modes

If you have the option, I encourage you to purchase a scanner with two modes: reflective and transparent. The reflective mode, which is when the scanner shines light from below the object, is usually what people think about when purchasing a flatbed scanner. This is the mode used to scan documents. If you can see through your object—if it's made of material with a transparent or translucent quality, you should try the transparent mode, when the light source comes from the scanner's cover, above the object. Most people think to use the transparent mode when scanning film.

Compare two images of the same material showing "fingering instability"—a pattern formed between two fluids. The image comes from researching that phenomenon in the lab of mechanical engineer Xuanhe Zhao. The first image was scanned in reflective mode (1.6a), and the second in transparent mode (1.6b). Which do you think is more successful?

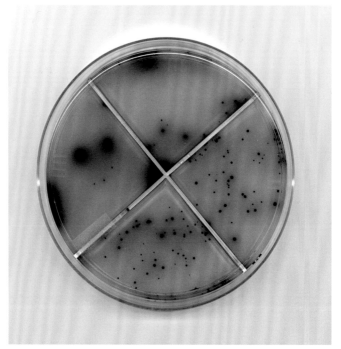

1.7a

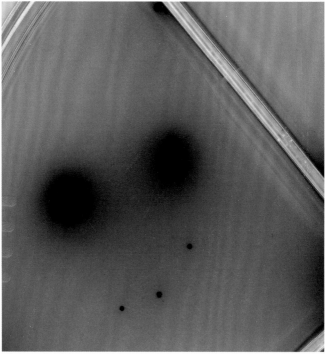

1.8a

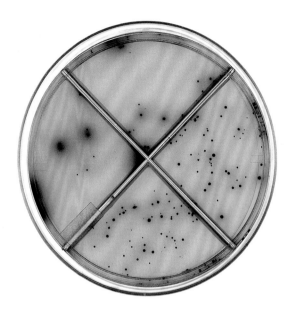

1.7b

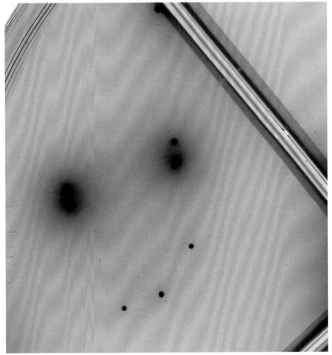

1.8b

1.9a

Or consider two images from the lab of biomedical researcher Sangeeta Bhatia, both of a petri dish growing *E. coli* bacteria (1.7a and 1.7b). Then consider the details of those images, zooming into both (1.8a and 1.8b). The second image, taken in transparent mode, appears clearer.

And here, consider two more images, this time of slides used in genetic sequencing created by the company Illumina. Because the first two slides are solid, preventing light from passing through, your first impression might be that reflective is a better choice (1.9a). Look at the other three slides on the right of that image, the ones placed at an angle. The last slide, using transmitted light, offers the viewer more information than the image in the reflective mode (1.9b).

1.9b

Something else that might be useful when using a scanner's "transparent" setting: I received a device, a cancer cell sorter (1.10a), in the mail from the lab of biomedical engineer Mehmet Toner. I scanned this highly detailed device in the scanner's transparent mode (1.10b). In the initial scan, the details were hard to see, but I knew they were there. After adjusting the image using computer software (chapter 6), we can see considerably more detail (1.10c).

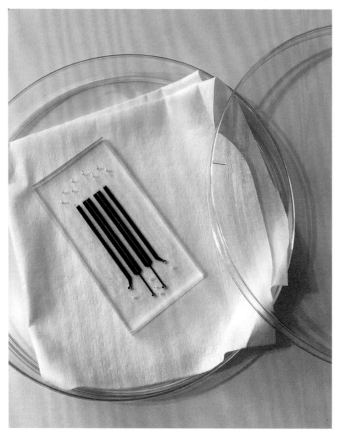

1.10a

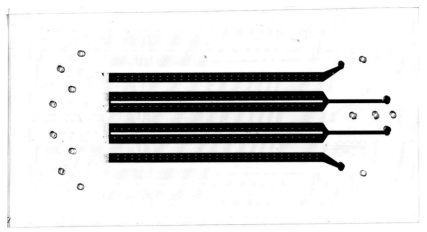
1.10b

1.10.c

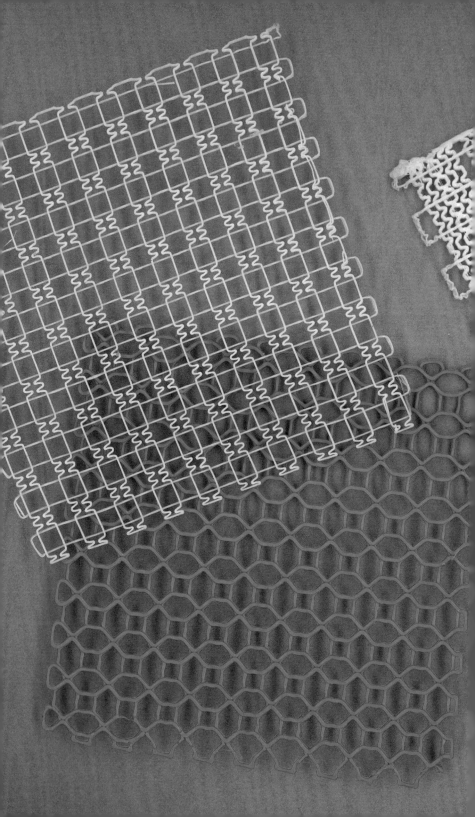

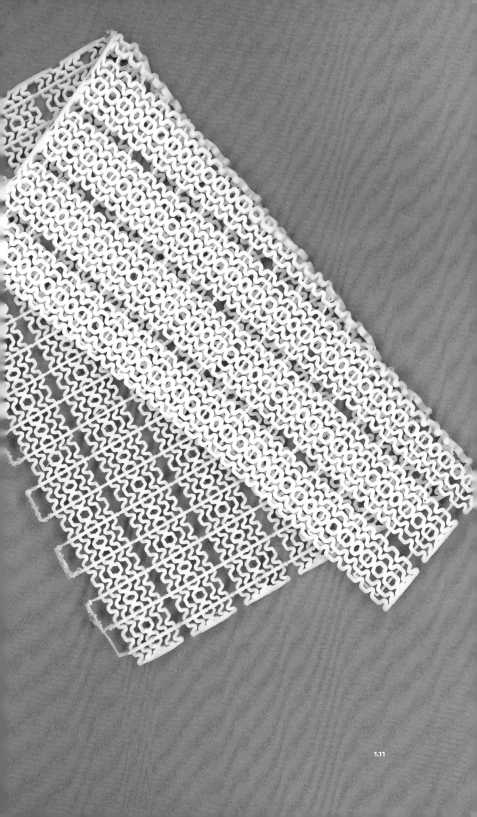

Backgrounds

Selecting the right background while scanning can help you make a compelling image. First, a well-selected background color can add to the image's design. I was in an orange mood when I used reflective light to scan these three-dimensional printed materials from mechanical engineer John Hart's lab (1.11). These meshes mimic soft tissue and are meant for ankle and knee braces. Where do you think I placed the orange paper before scanning? *On top of* the material, since the light and sensor are beneath the glass on the scanner's bed. Note that I folded the white sample to demonstrate its flexibility.

A clever background might also suggest a sense of scale. My wonderful student Malik Jabari placed a dollar bill over these micro LED chips, and his resulting image instantly gives the viewer an idea of the size of these small devices (1.12).

You might decide to add a background after the scan is made. Look at an initial test scan for a few gel-like coated catheters from mechanical engineer Xuanhe Zhao's lab to see how the material looks with reflective light (1.13a). I put them in petri dishes to add an interesting shape and scanned the first image. Later I digitally added a gradient (1.13b). I also changed the color for one of the loops since the colors were not scientifically important and I digitally increased their vibrancy.

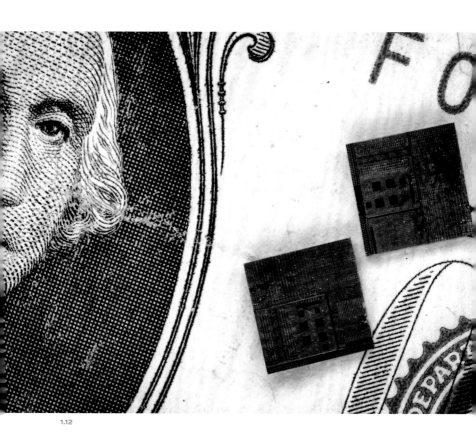

1.12

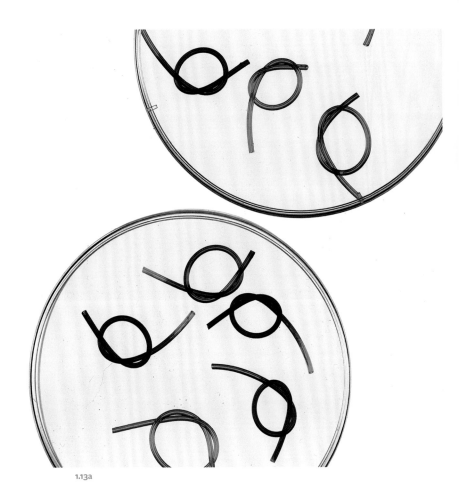

1.13a

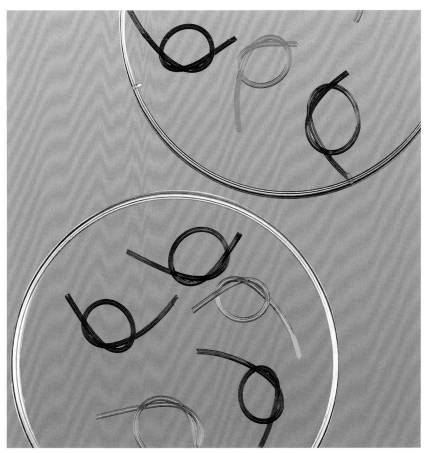

1.13b

Inversion

There are times when inverting an image's color can aid in communication. Most publications allow you to make such adjustments if the color is not informational (chapter 6). For example, when certain proteins are tagged with a colored fluorescent marker, the *amount* of color might be important. Consider a scanned image of a device completed in reflective mode, which was fine (1.14a). I later decided to invert the color of the image on the computer (1.14b). Notice the cropping I used to simplify the final image.

Look what inverting colors does for an image of a "lung on a chip," developed by cell biologist Donald Ingber and used for drug testing (1.15a and 1.15b). One might be clearer than the other, but the "better" image depends on whether the image will appear in print or online. Generally, images with a heavy black component don't reproduce well in print.

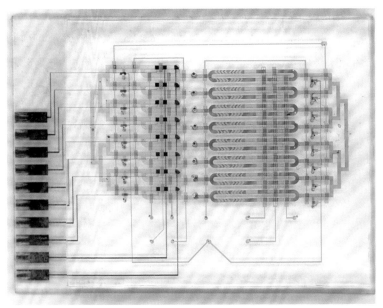
1.14a

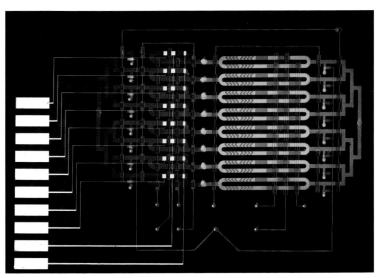
1.14b

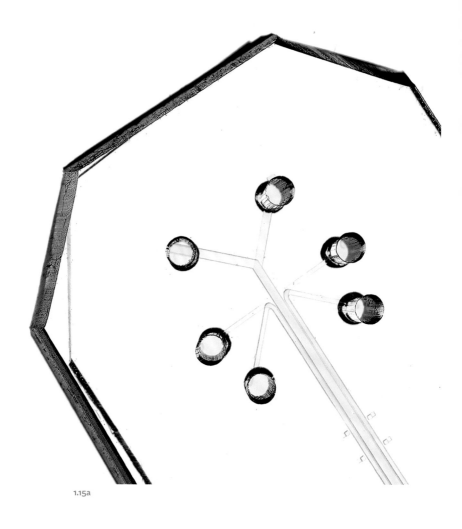

1.15a

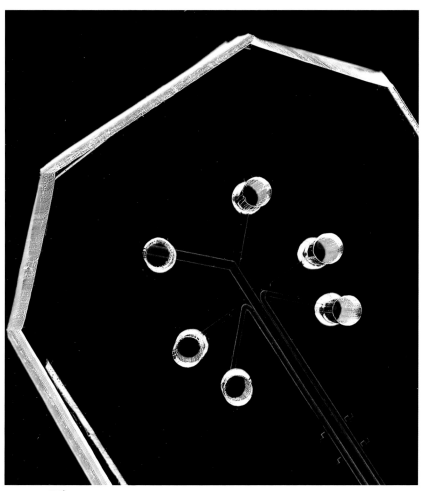

1.15b

Cropping

The best part of using a scanner is that you can start with a high-resolution image and then go to town on the cropping. The highest resolution I have scanned so far is 370 MB for an image of approximately 8 × 10 inches, at 1250 dpi. If your initial image is large enough in file size, you can zoom in on your screen and compose properly by cropping the image in software while taking your time with composition. A large enough file size for a scanned image is about 50 MB (an image about 10 × 20 inches at 300 dpi). This size will generally be big enough for you to crop, but you can also rescan for a higher file size if you want to really zoom in further for a final image.

For the original image, I had no idea how I was going to compose the final image. I started zooming in and came up with a crop (1.16a) and then the final image (1.16b), which shows remarkable detail.

1.16a

1.16b

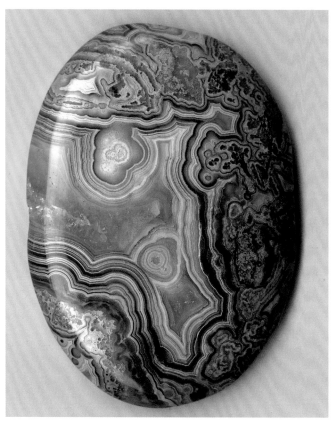

1.17a

Cropping, along with making other decisions on composition, is an exercise in clarity because it allows you to take a harder look at your picture and *see* the quality and detail that you might have missed when looking at the original scan. An initial scan of an agate rock was fine (1.17a). But then, when I decided to zoom in and crop the image to create a more interesting composition (1.17b and 1.17c), I also paid closer attention in the cropped images and literally *saw* more. Cropping was truly an act of discovery.

1.17b

1.17c

Fun with Eggs

I recently became obsessed with making images of eggs. Yes, eggs. I decided to place a few hard-boiled egg whites on my scanner. I then cropped that image (1.18a). I then decided to go even further: I poured a raw egg on the scanner on an area covered with a piece of glass and used a bowl to prevent the egg from spreading (1.18b and 1.18c).

1.18a

1.18b

1.18c

1.19

You Can Do This

I hope this chapter has encouraged you to try using the scanner, a surprisingly helpful piece of equipment, for your own work. John Rogers uses one in his work. His scan of several microfluidic devices used to analyze sweat shows that scanners work (1.19).

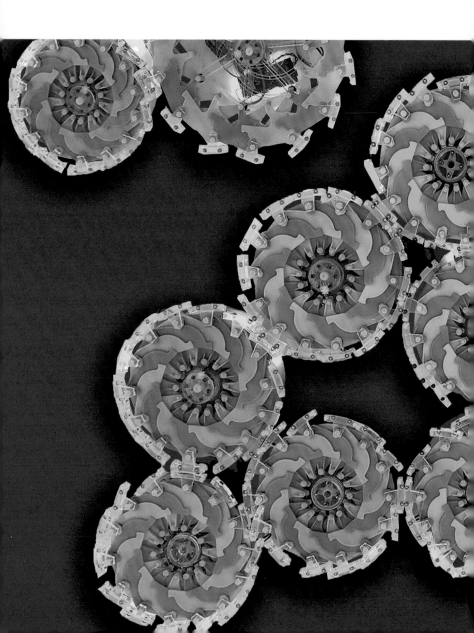

2
Phone

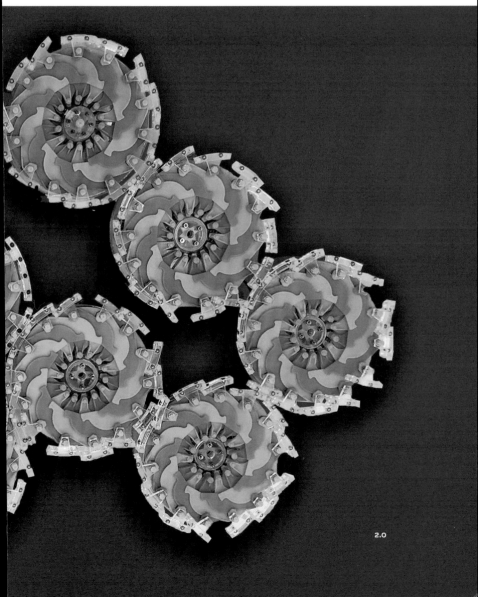

There is no question that photographs made with a phone have reached a new level of technical quality. The chapter opener image was taken with my phone (2.0). It is a group of miniature robots that communicate with each other. It even appeared on the cover of *Nature*!

When I first began gathering my images for my 2015 MITx course, Making Science and Engineering Pictures (which can be found at the website of MIT OpenCourseWare), I didn't consider including a great deal of images made with my phone. The quality of those images was not even close to what my professional digital single-lens reflex (DSLR) camera or scanner captured. Sometimes the color was completely off, especially in artificial light. For example, I used my smartphone to take an image when I visited CERN, the particle accelerator and high-energy physics facility in Geneva, Switzerland (2.1a). The blue hue in that image was definitely not what my eyes saw. To create something closer to what I actually saw, I digitally corrected the image (2.1b). We will discuss digital corrections in chapter 6.

Phone cameras also struggle with what's called depth of field—which is the distance between the nearest and farthest objects in your image that are acceptably in focus. At the time of this writing, new phones offer a mode for setting depth of field by computationally blurring the background. Why not just use a digital camera and get the real deal?

Don't get me wrong. Phone cameras are always improving. I use one for professional work, and you can too. Sometimes a phone camera is the best tool for the job, especially if you need an image to be a placeholder, or if you spontaneously capture a shot. Phone cameras can be incredibly useful, as you will see in the next pages.

2.1a

2.1b

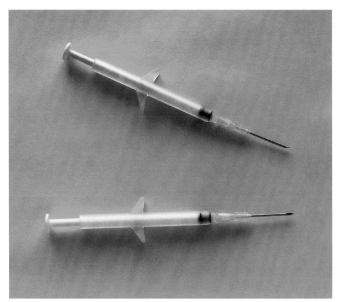

2.2a

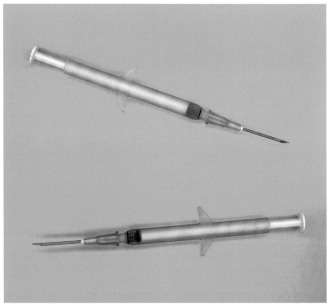

2.2b

2.2c

2.2d

File Size

Keep in mind that phones cannot currently capture the detail that a DSLR camera or scanner can. This is especially a problem when you need to enlarge an image. A phone just doesn't record enough information to be able to see detail. You've seen an example of this same issue with scanners in chapter 1. Consider two images: one I made with my phone (2.2a) and one with my scanner (2.2b).

My reason for making these images was to give my colleague Christine Daniloff, creative director of MIT's news office, a picture of a syringe to insert into an illustration (the result is in chapter 6). When I zoomed in on each image, the detail was lost in the phone image (2.2c) but kept in the scanned image (2.2d). The reason is the file resolution—the phone image has considerably lower resolution (and smaller file sizes).

Given all these concerns, you might ask how my phone image ended up on the cover of *Nature*. The answer: I kept the magazine format in mind when I captured the image. In other words, I didn't have to zoom in on the image to get the right composition, which would have resulted in a low-resolution file. Resizing the image on my computer to 300 dpi at 8.5 × 11 inches (a 24 MB file), the required size for a cover submission, gave me the file size I needed.

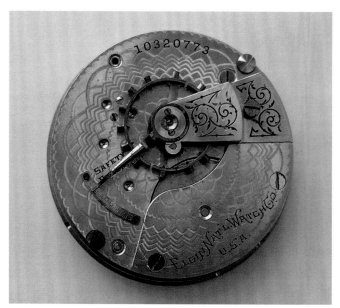
2.3a

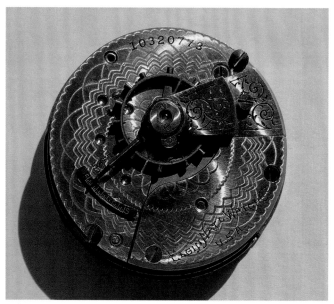
2.3b

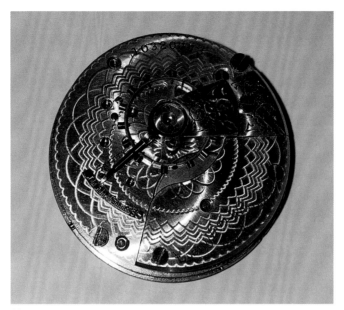

2.3c

Light

Covering the subject of light in a short handbook is challenging—there is so much to consider. It is *the* critical component when taking photographs. Light sources with the DSLR camera are described in greater depth in chapter 3, and those lessons are applicable for phone cameras, too. Few people think about light when using a phone camera. For the most part, I don't either. If I see something interesting, I grab the phone and shoot. I rarely put in the time to set up lights, as I do with my more "serious" DSLR camera. But for this chapter, I suggest just a few considerations pertaining to light when using a phone.

Remember that photographs are two-dimensional depictions of mostly three-dimensional scenes or objects. The image comprises all the captured elements *on one plane*, a flatland. Both shadows and highlights become part of the picture. Either can be distracting, but sometimes they can help define parts of the subject. Often, phone-equipped photographers do not see shadows or highlights because their mental focus is on other parts of the image, and they are viewing the image as a whole.

Consider three examples of a watch mechanism, all taken with a phone. For the purpose of this discussion, I converted these three images from color to black-and-white. I took the first with diffused light (2.3a), the second with strong sunlight (2.3b), and the third with the smartphone's flash (2.3c). The first is the simplest because your eye is not diverted by distracting shadows or highlights.

Look at the image of a rose, which I made without flash (2.4a) and then with the phone's flash (2.4b). I prefer the image made without flash. In this instance, the shadows help define the structure of the flower. The second seems unnatural to me. For science pictures, I suggest that you turn off the flash and not use any automatic flash settings while photographing your research.

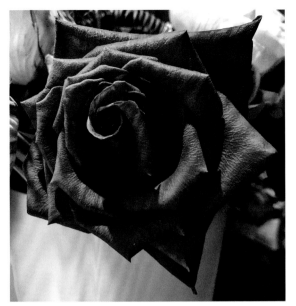

2.4a

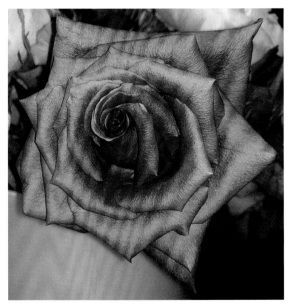

2.4b

Color

The latest smartphones have certainly improved their ability to capture color from the time of that blue photo I took at the start of the chapter (see 2.1a). Years ago, smartphones were programmed to automatically adjust the final image to a particular contrast and tint, chosen on the basis of what the phone's manufacturer believed would appeal to most users. If you think about it, some computer programmer, with the encouragement of management, had been tasked with creating that final image and its particular look. Those adjustments are still happening with today's phones, but they have more "realistic" outcomes. You can try switching off those adjustments if your phone offers that ability in its settings. But, if a color comparison in one image is vital to your work, stick to a DSLR camera, which will give you more control over the color in your final image.

Let's go back to that watch mechanism, but this time look at the three original color images. I took the first with diffused light (2.5a), the second with sunlight (2.5b), and the third with flash (2.5c), all with my smartphone. The background for each image was the same white paper, but notice how differently the phone camera "interpreted" the color in each image.

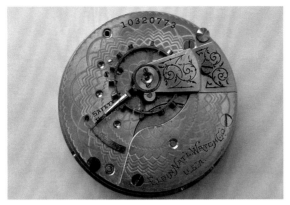

2.5a

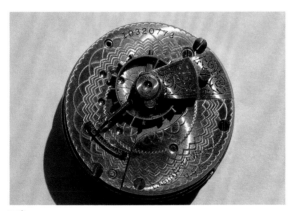

2.5b

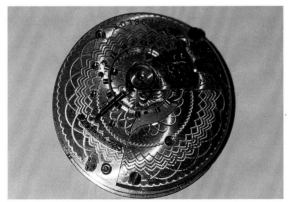

2.5c

Fixes

Now is a good time to bring up the subject of "fixes," the adjustments you can make after you have taken a photograph. An important principle of photographing your work, with any instrument, is to get it right from the start. You should not rely on fixing an image after you make the picture. But there are times when a certain fix will benefit the final image. I make fixes using Adobe Photoshop software. How far are we permitted to go when we digitally alter an image? In science photography, it's critical to maintain scientific integrity. The fixes that I offer here for images captured by a smartphone do not change the data, if *data* is the structure of what we are imaging. I devote chapter 6 to a detailed discussion of image integrity, but the following sections cover some basics.

TO CROP OR NOT TO CROP

For the most part, simple cropping after taking a picture can have a powerful effect in creating a more communicative image. Cropping helps direct attention to what you want the viewer to see first.

The following are two examples of how cropping can make the subject of an image more readable and perhaps more engaging. For this exercise, I knew I didn't have to get the perfect image at the start and that I could fix the image later. This was a gift since I had very little time to finish the project, and it gave me the opportunity to be more creative.

The first image was the original made in the lab of the materials scientist Jennifer Rupp. It shows a chamber where various reactions take place, used in the study of various materials (2.6a). I decided to tightly crop the original image (2.6b).

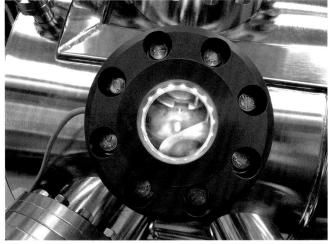
2.6a

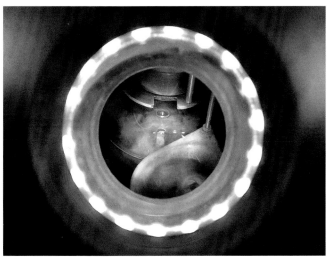
2.6b

2.7a

Consider another example, the interior of a piece of equipment (2.7a). The cropped image (2.7b) is more "generic"—to be used as a graphic element, to give a visual sense of work in the laboratory. These are the kinds of images that can be beneficial to include on websites. I encourage you to walk around your lab and take photos with your phone's camera and then crop them: use the cropped details instead of stock photos to tell a more personal story.

2.7b

Another example shows where I might have overcropped. I took the initial image because I saw some colorful optical effects at the windows (2.8a). I framed it, thinking that the composition was interesting. But then I decided to crop further because I wanted the viewer's attention to go to the phenomenon of the optical effect (2.8b). It became a less interesting image. What do you think?

2.8a

2.8b

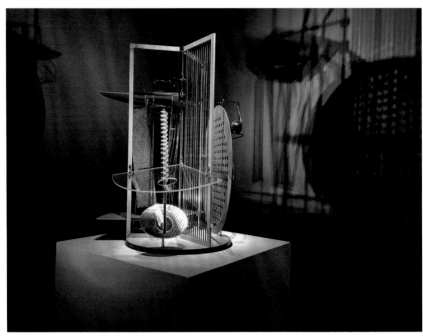

2.9

Consider an image that I made in Berlin in the Bauhaus-Archiv design museum (2.9). It is a 1930 sculpture by László Moholy-Nagy, titled *Modulator 22 (Light Space Modulator)*. We see that the shadows cast by the sculpture add to the understanding of the subject and, at the same time, make the image more interesting. I left the image alone and didn't crop it. Note also that I composed the image with the subject off-center. Imagine if every photo had its subject smack in the middle.

DELETING BACKGROUNDS

Often, when I am shooting with my phone, I am in a rush (otherwise, I would be using my DSLR camera). As mentioned earlier, I always have in mind that I can fix images from my phone later. Consider this image of a rheometer, which measures how

2.10a

2.10b

a liquid flows in response to force (2.10a). I later digitally deleted the background, carefully removing the distracting equipment pictured in the background. I then filled that part of the image with a neutral color (2.10b).

2.11a

2.11b

Let's say you want to show an apparatus to a colleague quickly via email. You can surround the equipment with white paper to hide a busy background and then take a photo with your phone (2.11a). Later you can digitally delete the paper edges to make the photo more presentable (2.11b). I use Photoshop's Healing Brush tool.

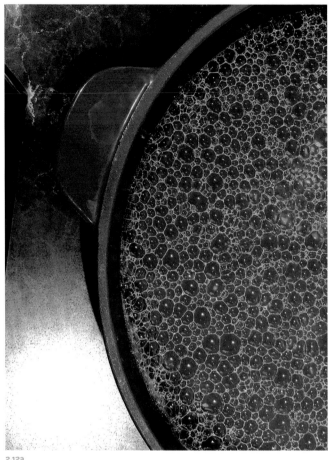

2.12a

Here's another type of background fix, this time adding a little something to the image after deleting the clutter. I took an image of a pan on my kitchen countertop that I had used to make a terrific Bolognese sauce (2.12a)—if I do say so myself! I first put some dish soap and water in the pan to prepare it for cleaning. I was fascinated by the formation of bubbles that were outlined by

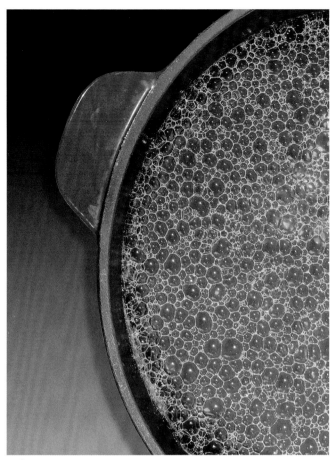

2.12b

fat. I grabbed my phone camera. I liked the image, but the background was distracting. In Photoshop, I selected the background and used a gray gradient to "fill" the background in. I then added a drop shadow, which subtly brought the image to life (2.12b). Again, don't worry too much about the Photoshop techniques I'm describing now. There's more on them in chapter 6.

A PHONE ADAPTER FOR A MICROSCOPE

Du Cheng, the founder of LabCam, a company that produces a phone adapter for microscopes, gave me one of his adapters to try (2.13a). It changed my life. If you have ever tried placing your phone in a microscope's ocular to make the perfect image, you will understand the frustration in trying to get it right. Look at an image I made of oil, vinegar, and surfactant in a glass dish with my dissecting microscope (2.13b) (we'll discuss types of microscopes later).

Consider another image I made with the adapter, this time through my compound microscope (2.14). Samantha McBride's research shows how crystal spirals can form from evaporating saline drops. We submitted this image for publication, and the journal's editor selected a similar image for the cover.

2.13a

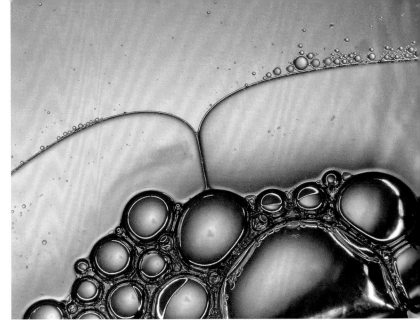

2.13b

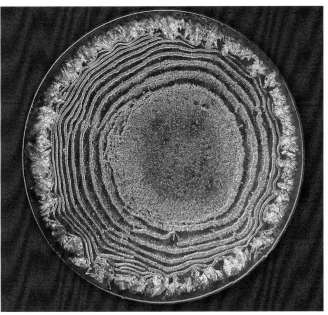

2.14

On Assignment

I am convinced that creating many images will allow you to explore your thinking and imagine better compositions. Consider an initial image that I made of experimental materials by the material scientist Elsa Olivetti (2.15a), who is committed to "moving us to a more sustainable world" by developing new types of renewable materials that are recyclable or compostable. The image shows the fabrication stages of a type of cement. The image is fine as it is, and I liked the subtlety of the shadows—they are interesting without being distracting. Still, I decided to push it a little further. I placed the samples on a yellow plastic sheet and then put everything on a light table, used for looking at photographic film, to get a more interesting background. The resulting image is more dramatic but not necessarily better (2.15b). What do you think?

In this next case study, for a cover submission, I started out using a phone camera because it was an easy way to see the possibilities. Chemical engineer Liang-Hsun Chen, in Pat Doyle's laboratory, was developing a process for packaging a drug. I wanted the image to suggest the process (2.16a). I used one of my laptops as a background because the golden color worked well with the mold for the pills. Take a look at a few edited images (2.16b–e). There were many more! Getting the right composition takes time, and that's why I've just bombarded you with images to consider. See how I moved things around, changing the camera angle and the placement of the vials and pills?

2.15a

2.15b

2.16a

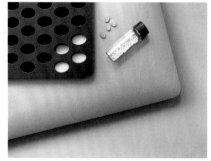

2.16b

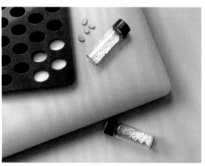

2.16c

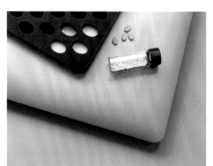

2.16d

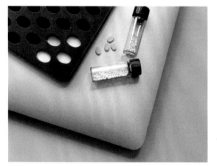

2.16e

2.16f

I made the final image with my DSLR (2.16f), which gave me better image quality for a cover submission. Note the interesting shadows from the pills in the vials. These shadows were not as pronounced in the "practice" phone camera images, when the light was coming in from my studio window on a sunny day. And yes, there is a slight change in color from the other images because the last shot was taken at a different time of day, not to mention with a different camera. Changing your light source is an element you can consider if you do not have a permanent setup for photography, and it can be fun. I would go crazy with boredom if I used an identical setup for all my shoots.

2.17a

2.17b

2.17c

In another study, consider an image that I created for the MIT news office. Mechanical engineers Sarah Wu, Hyunwoo Yuk, and Jingjing Wu, of Xuanhe Zhao's lab, first sent me a number of examples of their paper-like medical patches, created to replace sutures and staples in some surgeries (2.17a). The origami-like designs can fold around surgical tools and transform into soft, strong adhesives when pressed against body tissues. It is always critical to simplify your visuals (an ongoing theme in this book series) so that the reader can immediately see what you want them to see: in this case, simplifying and editing resulted in the final image (2.17b), which was used by the MIT news office (2.17c).

Suggested Exercises: Creating Your Own Case Studies

Here, I outline a few exercises for you to try with your own phones. I suggest doing these exercises in a group. All participants can then meet and review the images taken.

COMPOSITION

Walk around your lab and create five images in detail of one of your instruments. Don't try to get an entire piece of equipment in the image—just a detail. Use a different composition for each one. Study the five and determine which would best work on your website as a "cool" image and which would be best as a documentary image—to show in a slide presentation, for example.

BACKGROUNDS

Take a small instrument (e.g., pipette, scissors, test tube rack) and lay it on three different backgrounds. Study the three and critique which works and which doesn't.

SCALE

Place one of the above small instruments on your preferred background, next to something recognizable (not from the lab, like a dollar bill as mentioned earlier), for the purpose of showing scale. Try three different compositions and take photographs. Then decide which works best.

LIGHT

Take one of the small instruments and image it with three different sources of light: from the window, under fluorescent lab lights, and with a lamp. Study and compare color, shadows, and highlights.

A phone is a helpful tool for when you want to walk around your lab and quickly make images for your website. Your first inclination might be to concentrate on your equipment and images that suggest your science. That can work, but I encourage you to also look at some "generic" subjects—pencils, pipettes, glue, and glass—which might not be specific to your work but can help bring attention to your website.

3
Camera

I hope this chapter, which addresses the fundamentals of using a DSLR (digital single-lens reflex) camera, will help you see your research in a different light. I mean that both metaphorically and literally. With good equipment and the knowledge of how to *use* it, you will find that making an image for the purpose of communicating to others will become an act of discovery about your own work. I am confident that you will learn to *see* differently and will keep an open mind about what it is you want your viewers to see. I am making the assumption in this chapter that you have some knowledge of how to use a camera. If not, please consult your camera's instruction manual. For example, I do not go into expanded details about how to set exposure and only minimally address the subject.

I was walking around my home years ago, holding a prism in my hand, just for fun, and there it was, a moment of wonder. The white sunlight coming through the hanging window blinds refracted into its stunning spectrum. I just *had* to photograph that spectrum. I set the prism's corners against two black boxes to get the final image—with my "real" camera, the DSLR. Incidentally, I recently tried to imitate the image with my phone. It just didn't work. The phone's lens distorted the image and didn't give me the simple image you see in the image that opens this chapter (3.0).

The Basics, Part I

EQUIPMENT

Camera Manual

Yes, the camera manual is part of the equipment. Make sure you read it. Many researchers love to figure things out on their own, but sometimes this can be a waste of time. Believe me—there will be many other opportunities to figure things out on your own.

Camera

Let's start with what you do not need—a camera with all sorts of bells and whistles. You will not use most of them. What you do need is a 35 mm DSLR camera with a CMOS sensor (a chip that converts photons to electrons for digital processing). Select a camera that will give you the largest file sizes available. Keep in mind that larger files will give you the ability to enlarge your image while still maintaining a good resolution, so starting with a large file size is helpful. At the time of this writing, the sensor in my Nikon D850 captures 45.7 megapixels.

Lens

I rarely use any lens other than my 105 mm macro lens. For the kind of photography discussed in this book, this particular lens allows you to get very close to the subject and take photos of great quality. Do not use lens filters. Just take good care of your lenses. You pay a lot of money for a quality lens, and placing a low-quality filter over the lens will change the optics. I also use a normal 50 mm lens on the rare occasion when I am shooting equipment.

Tripod

Don't even think about making an image without a tripod. Yes, it slows you down. But sometimes it's good to slow down! Taking your time will allow you to look more carefully at your potential

setup rather than taking a quick shot. You might also enjoy using a quick release for the tripod. These make it easy to detach and reattach the camera to the tripod, which is especially helpful if you plan to move the camera around and want to experiment with placement.

Another, more important reason for using a tripod is that it helps create a better image if you are required to use a slow shutter speed when there is not enough light for the proper exposure. You will be able to shoot because the tripod will stabilize the camera, even at a very slow shutter speed. I don't know about you, but I cannot possibly get a quality image if I am shooting handheld at 1/30th of a second (see the section below on exposure for more information).

SOFTWARE

During a shoot, connecting your camera directly to your computer using the appropriate software has a number of benefits, including these:

- You can easily see all elements in the enlarged image on your screen, which you might miss by looking only in your camera's viewfinder.
- You can see what is and what is not in focus on the screen.
- You can immediately see the composition and change around components while in "live view" on your computer. Live view gives you the full image the camera is capturing right on your computer screen.

I encourage you to visit MIT OpenCourseWare for my tutorial Making Science and Engineering Pictures to see exactly what I mean.

EXPOSURE

Exposure settings determine how much light from your subject reaches the camera's sensor. As I mentioned in the introduction, I *do not* use automatic settings. The more *you* control the

exposure settings on your camera, the more creative you can be with your images. The three basic settings to determine exposure are these:

1. ISO: the light sensitivity or signal gain of the sensor.
2. F-stop = the size of the aperture of the lens.
3. Shutter speed.

You'll have to read the camera's manual on how to change these settings for your particular camera.

I always encourage setting the ISO as low as possible. This reduces "noise"—extraneous electronic signals—and is another reason you should get into the habit of using a tripod. At a low ISO setting (decreased sensitivity), your camera's sensor will mostly capture what your camera "sees" in the frame, with little noise. When using a tripod, you will not be limited to your f-stop or shutter-speed settings.

The most interesting and creative setting is your camera's aperture. Changing the aperture setting (f-stop) adjusts the size of the lens opening, letting in less or more light. The setting also changes the depth of field. Depth of field describes what is in focus (and what is not in focus) in a picture.

For most of the images in this handbook, setting the shutter speed should be straightforward since your subject will not be moving, and once again, you can stabilize the camera on a tripod if the right exposure requires you to shoot at a slow shutter speed.

Preparing Your Sample

I encourage you to put aside a couple of devices and other materials to use specifically for photography. Keeping a cache of camera-ready devices will alleviate frustrations later on. In addition, it's important to prepare a sample of work that is separate from your experimental work. That sample will be in good shape to photograph and thus will better *communicate* the science, as we see in the next examples (note: I used a tripod for all the upcoming images).

Let's talk about an image I created in 1992, when I first began photographing science. My steps for revising and editing this blue and green image would forever change my thinking. At the time, I had invited myself to the lab of chemist George Whitesides, just when the journal *Science* had accepted a paper written by him and postdoc student Nick Abbott describing a potential application for creating patterns on a special surface. Later, the technique came to be used in many labs and was called "soft lithography." The lessons from making the image have stayed with me. The journal article used another image that the researchers made in the lab (3.1a). It shows a gold surface patterned with hydrophobic lines that outline various shapes when water drops onto the surface. The areas within the lines are hydrophilic—the water spreads and stops at the lines. The

3.1a

3.1b

rectangle in the image measures about 4 mm across. The key to communicating the science was to show the ability to create hydrophobic and hydrophilic areas on a surface so that water is contained within the hydrophobic lines and does not mix with other shapes.

My first suggestion was that the researchers use a more interesting visual pattern, like a grid. Next, I dropped water with blue

3.1c

and green fluorescent dye on the patterned surface to distinguish the sections. I lit the sample with both overhead ceiling light and small UV lamps. I was pleased with what I believed was the final image, perhaps to be used for a cover submission. In fact, I even composed the image so that the *Science* logo could be placed in the empty space at the top (3.1b). Then came that important educational moment. The editors at *Science* believed that the image was ambiguous. Why are there two tones of green and of blue? Does that have something to do with the science? The answer was no, and I had to rethink my approach. I went back and reshot with more diffuse light, resulting in the final image (3.1c). This made the cover of *Science*. Compare the researchers' image with my own. Their text discussed the science in the article, whereas my image *showed it*—the lines prevent the colored water drops from blending together.

Having to rethink the image was an important lesson, and I now always ask myself, "Am I clearly communicating the science in my image?" Consider asking yourself the same question.

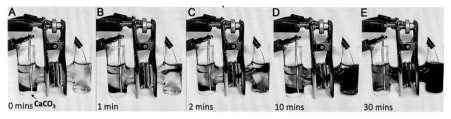

0 mins CaCO₃ | 1 min | 2 mins | 10 mins | 30 mins

3.2a

3.2b

The experience of Leah Ellis, in Yet-Ming Chiang's materials science lab, provides another example of rethinking your preparation. She created an electrolyzer apparatus and an image of it (3.2a). The demonstration setup shows the basic chemical reactions used in a new process to help manufacture more environmentally friendly "green cement." The figure was just too busy, and I couldn't figure out where to look. Researchers don't always recognize this problem in their own photos. This is because they know what to look for and assume their viewers all look at what they want us to see. Sometimes it's helpful to ask someone not involved in the research what they think is the focus of an image. In this example, I first asked Leah if it was possible to create the demonstration without the big (and distracting!) clip that held together the two chambers. She worked hard to make that happen. I then made new images of the apparatus over time (3.2b). They are not as busy and easier on the eye. By the way, I took about nine images while the water was changing color. You can see an animated GIF of the process on MIT's website (http://www.mit.edu/spotlight/green-cement/).

The Basics, Part II: Light, Depth of Field, Point of View, Backgrounds, and Composition

It's difficult to separate out the concepts of lighting, depth of field, point of view, background, and composition. They all are determined in tandem. For example, when you adjust the lighting, you're going to get a different kind of shadow, and that shadow becomes part of the composition. So, while I have separated concepts into decision-making categories in this section, it is important to keep in mind that they are closely connected.

LIGHT

Students always ask the best way to light a subject, and they never are happy with my response: "It depends." If I am pushed to come up with a first line of thinking, I would suggest using somewhat diffuse light. Light coming from a window (not strong sunlight) can work. A ring light (now popular for Zoom meetings) can also be very useful for shadowless images. Avoid lighting that gives harsh shadows unless—and here is the caveat—the presence of a shadow contributes clarity to the image. In an image of a structure fabricated in the lab of chemist George Whitesides (3.3), there is strong light coming from the left, resulting in a shadow that echoes the structure. The shadow adds to the aesthetics of

3.3

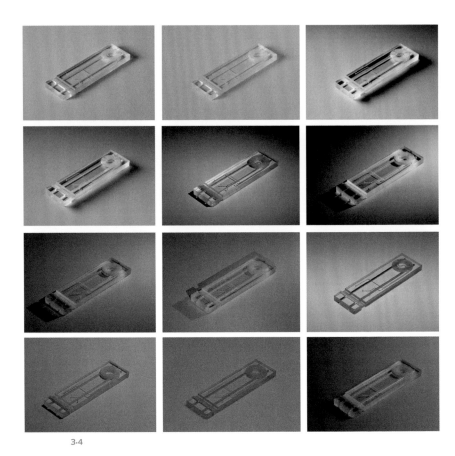

3.4

the image. But you must be careful: Shadows become strong components of images. If not handled properly, they can become a distraction.

It is helpful to look at examples of lighting a particular subject to see the very different final images that result. Note the diagram that includes some examples of setups (3.4), and note the changes in each image as I made various adjustments, like raising the light source or adding a white card to "fill" unnecessary shadows. I encourage you to study that diagram and then

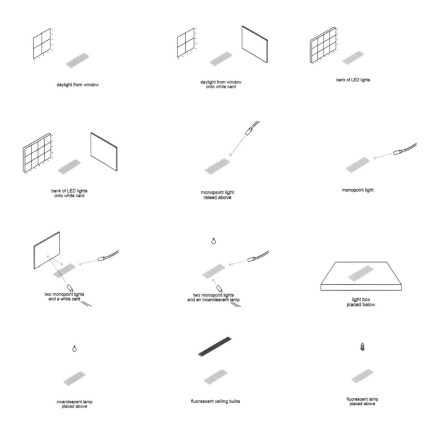

apply the ideas to your own work. You will notice that I do not include flash. Using flash successfully requires a sophistication that comes with practice, and that translates into time. Practicing first with the setups in this diagram is a step toward achieving that sophistication.

You can also visit an interactive tool to see how various light setups give you different images. Look for Week 3—Light, Interactive D2Lighting Comparison in the course Making Science and Engineering Pictures at MIT OpenCourseWare.

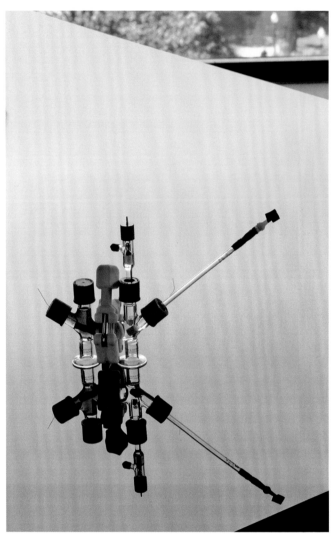

3.5a

3.5b

3.5c

Case Studies in Light

I was asked to image an experimental setup for a potential cover of the journal *Cell*. The materials scientist Liang Su, of Yet-Ming Chiang's lab, wanted to photograph a low-cost electrical storage apparatus. I placed the object on a mirrored table, with light coming through a window. My idea to include the reflection was a mistake (3.5a). The reflection was just too strong in this setup and made the image confusing. I switched to using a light box in my studio for the background and as a partial light source (3.5b). Knowing that the light from the box would not be adequate because the device was so dark, I added a warm light source directed toward the front of the apparatus, with this being the final image, with a little cropping (3.5c).

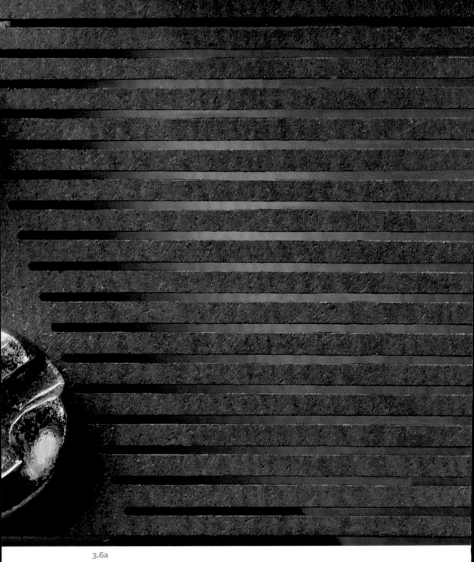

3.6a

3.6b

Another time, I shot the mechanism inside a music box (3.6a). Lighting it with a combination of daylight from a window and an overhead tungsten light resulted in a surprising combination of colors (3.6b). Now, I rarely use tungsten and have replaced all my bulbs with LEDs.

For the MIT News office, I was asked to create an image of a simple chip from the work of materials scientist Cecile Chazot in Mathias Kolle's lab. The chip uses quantum dots. When these dots are "excited," they emit light that allows researchers to see microorganisms. I used the light from my microscope to bring attention to the chip (3.7a). In a separate image, I held a UV lamp over the chip to depict what happens in the chip when the quantum dots are excited (3.7b). I then digitally inserted only the chip from that second image into the first to create a photo illustration (3.7c). The final image shows another photo illustration (3.7d). Try to imagine these two images shifting back and forth in an animated GIF.

3.7a

3.7b

3.7c

3.7d

For another project, a cover submission, biomaterials researchers Omid Veiseh and Joshua Doloff sent me samples of new materials developed for use in breast implants. I randomly arranged them on a light table, making sure in the composition to leave room for the journal's logo at the top (3.8a). I lit the image with an LED light developed by the company PHLOX, which provides a good amount of light and shadows. Compare the setup (3.8b) with an image with the PHLOX light on and with the light focused (3.8c).

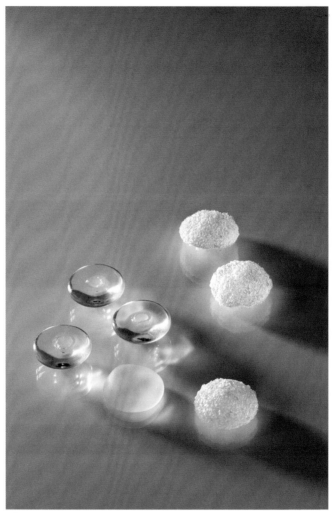

3.8a

3.8b

3.8c

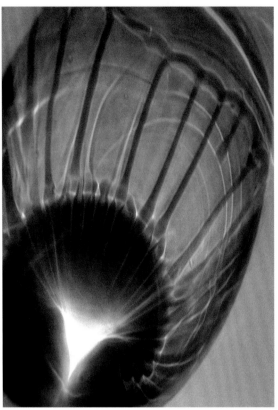

3.9

Special Cases

Let's look at a few unusual approaches to using light. For our book *On the Surface of Things*, George Whitesides and I wanted to show an example of what's called the Marangoni effect, which is created by the tension between two fluids on a surface. Some call it "tears of wine." After trying a number of setups, I decided that shooting the shadow made the best image (3.9).

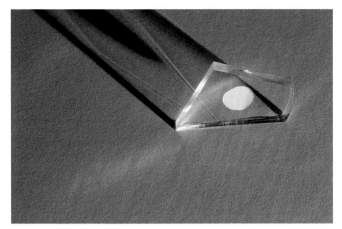

3.10a

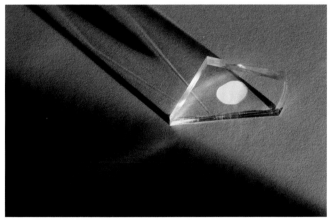

3.10b

Years ago, the team in George's lab imprinted the surface of plastic with a pattern that broke up white light into its spectrum. When I first made the image, that spectrum was hardly discernible (3.10a). I then held a piece of cardboard near the light source, creating a shadow at the spot to make the spectrum's various colors more visible (3.10b).

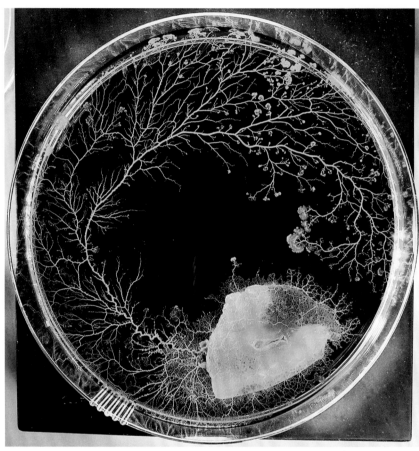

3.11

Some examples of light sources might surprise you. I asked Nirosha Murugan, who works with slime molds, if I could use her stunning image (3.11). To make it, she first put a petri dish on a dark-blue opaque film and then put both the dish and the film on a light pad. The result turns out to have a similar look to darkfield microscopy, in which the light source is directed around the perimeter of a material.

For the most part, photographs of fluorescing material require long exposures, which is possible when using a tripod. In one shoot, I wanted to image a series of vials containing cadmium selenide nanocrystals from Moungi Bawendi's chemistry lab. We excited the nanocrystals with two ultraviolet lamps, and each vial fluoresced at different wavelengths (3.12a). Subsequent images show plastic rods that have absorbed the nanocrystals. One was taken with UV illumination while keeping the room lights on (3.12b). Another was captured with the room lights off (3.12c). You decide which one is better.

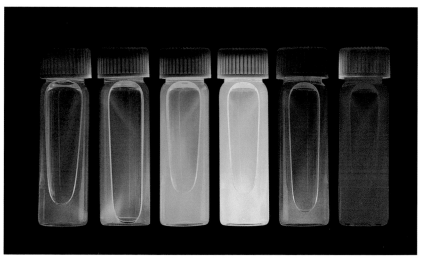

3.12a

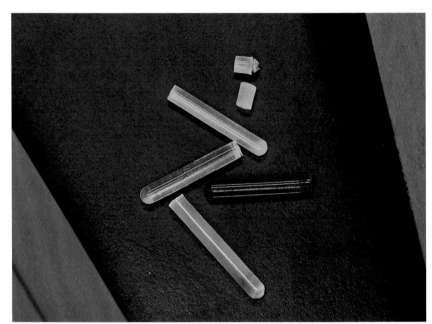

3.12b

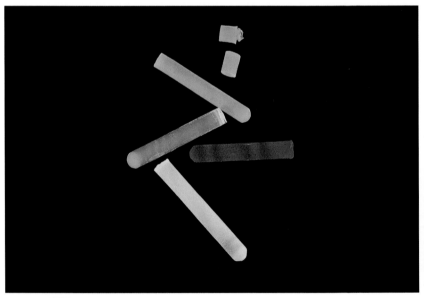

3.12c

DEPTH OF FIELD

As I wrote before, setting the lens aperture is one element to consider when finding the right exposure. The aperture setting determines how much of your image and which part of it will be in focus. You can view the chosen setting—the f-stop—in your camera's viewfinder and in the appropriate window in your software. I have two 105 mm macro lenses. For the older one, the aperture settings can be adjusted by hand on the barrel of the lens or in software. For my newer lens, the aperture can be adjusted only electronically. For the older lens, to see what will be in focus through the camera's viewfinder, I have to press the Preview button, and the aperture will close down to the chosen f-stop. You then will see the image with the specific focus created by that particular f-stop. But keep in mind that, because the preview makes the aperture smaller, the image will become dark and will be difficult to see. This is another reason I like using software during a shoot; there is no need to press a Preview button. In the software's Live View mode, the image with the chosen aperture appears on the screen without any darkening, making it much easier to see what is in focus.

3.13a

3.14a

Observe the focus for two images of the watch mechanisms we saw in chapter 2. In the first, at f/2.8, not very much is in focus in the foreground or background (3.13a). The second, shot at f/29, is almost completely in focus (3.13b). Consider the differences in details of another device as well, also taken at two different f-stops (3.14a and 3.14b).

3.13b

3.14b

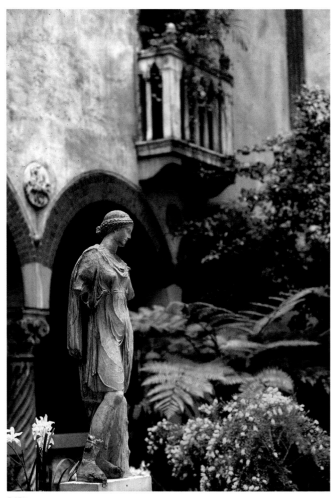

3.15a

Now consider these images taken with my 105 mm macro lens at the Isabella Stewart Gardner Museum in Boston, on a tripod, using two different aperture settings. The first is set at f/4 (3.15a), and the second is "stopped down" to f/29 (3.15b). Compare the two. Look carefully, especially at the background.

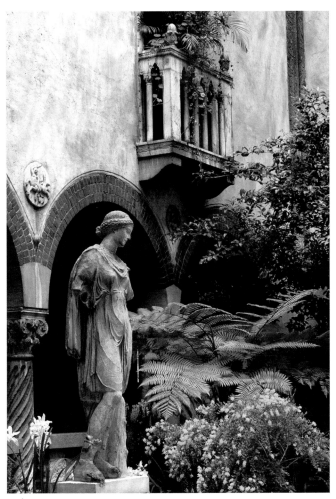

3.15b

Remember, as you close the aperture, or stop it down, to smaller settings like f/29, you decrease the amount of light let into the camera. To get the right exposure for your image, you will have to compensate by slowing the shutter speed, which increases the amount of time the shutter is open during your shot. For example, when you change the shutter speed from one second to two seconds, the shutter stays open twice as long, which allows more light into the camera.

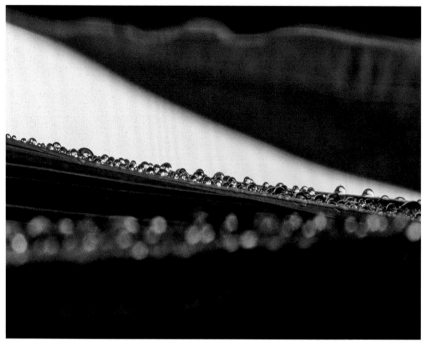

3.16

Consider another relevant image, this one showing an intended narrow depth of field, with very little in focus (3.16). I took it at the Bloedel Reserve on Bainbridge Island, Washington. Of course, I used a tripod.

A Special Case
There will be times when you will not be able to get all you want in focus, even when you have stopped down to the smallest aperture. In such a situation, you might consider the technique called focus stacking. In focus stacking, you create a series of images (five or six) at different focal planes, progressively moving from the foreground to the back. Each image is taken from an identical point of view and with identical exposure. The only difference among the images is that you focus first at the foreground and

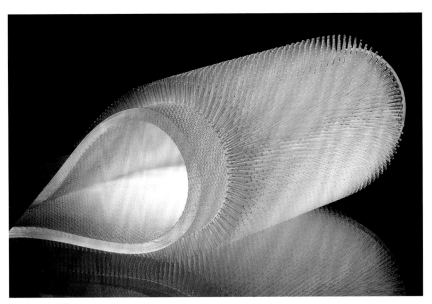

3.17

work yourself to the back of your subject, basically making slices of images. Using software, you can stack the images to create a final image that has the depth of field you want (3.17). We'll see some amazing stacked images created by some talented photographers in the next chapter.

POINT OF VIEW

Consider the multiple images of Will Langford's robotically constructed capacitor, each taken from a different point of view (3.18). I also changed the backgrounds, but for the most part, for four of the images, I simply moved either the sample itself or the camera to a different angle. One was made on the flatbed scanner. Which one is the "right" one? Or is there no such thing?

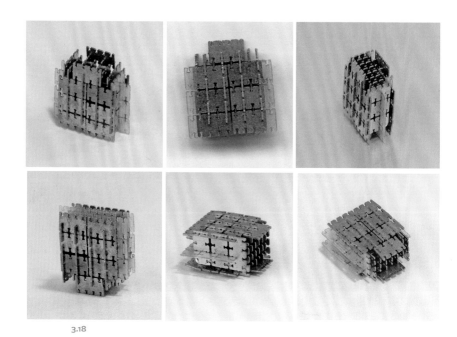

3.18

Another image shows the flexibility of electronic material made by the physical chemist John Rogers (3.19a). He included hands in the composition to suggest scale, which works well. For a cover submission, I later began to play around even more with the material's flexibility, including some reflections and shadows in the image (3.19b). The journal liked this point of view so much that the image was chosen for the cover—always nice! It is not clear, though, that one image makes a better point of view than the other—something to think about.

3.19a

3.19b

3.20a

BACKGROUND

A potentially important part of making good photographs, especially of small devices, is choosing the right background. The selection of the right background can really add to an image, but it's also important that the background not detract from what is being communicated.

Let's return to the example of the music box's mechanism. The issue in one composition is the horizontal line where the table meets the wall (3.20a). To address this, I placed a piece of paper curving up from the table to the wall, being careful not to crease the paper (3.20b). This provides a nice background without that distracting border.

In another example, consider the fabricated polymer shapes from George Whitesides's chemistry lab (3.21). I first printed a grid on acetate for the background and used a light table as the light source. I liked the effect of the optics of the polymers on the grid beneath them.

3.20b

3.21

3.22

For the lab of chemical engineer Bob Langer, I placed insulin-delivering drug capsules on a simple background (my old MacBook). Take note of the composition (3.22). Do you remember this laptop background trick from earlier?

In another image, I attempted to visually suggest the flexibility of a small electronic device from John Roger's lab by adhering it to an irregularly curved background (3.23). John asked me to show the device on skin to show its ultimate use. I dissuaded him from that idea because of my concerns about being too literal. In this case, I tend to avoid close-ups of skin to prevent what I call the "yuck factor."

That said, I'm certainly not against showing the human element in the fabrication of complex technology. Consider some hand-drawn sketches of the design for a device, placed behind the device itself, which is an autonomous robot from researcher Rob Wood's lab (3.24).

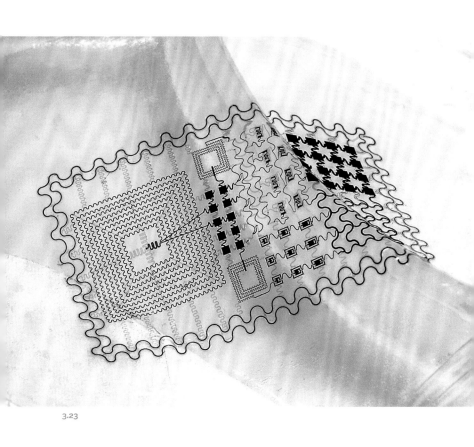

3.23

For another image, one of *B. subtilis* bacteria growing in a petri dish, I decided to layer a couple of backgrounds. I first placed the petri dish on blue plastic and then put both the dish and the blue plastic over orange plastic. Also, note the composition—the dish is off-center (3.25).

3.24

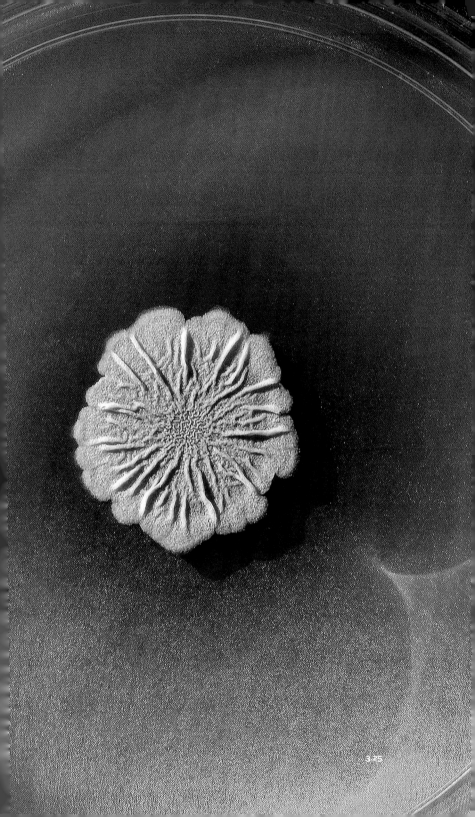

3.26

COMPOSITION

Composition is a powerful tool to help viewers discover where and how to look at your image. Look at a detail of a large piece of opal (3.26). Initially, the image looked chaotic, with no focal point. After studying the piece in my camera's viewfinder and moving it around, though, I found the triangular form to be an organizing element.

I want to encourage you to experiment and play when composing your images—don't always stick your subject smack in the center of the frame. In addition, ask yourself if you really must show the whole subject. Maybe focusing on only a piece of your subject is enough. For example, consider a glass wafer with channels etched on the surface. In one photograph, I framed the device in the center of the composition, the way that most researchers would (3.27a). For another image, I composed the device more toward the side of the frame, which in my opinion shows enough of the material and makes for a more interesting composition (3.27b).

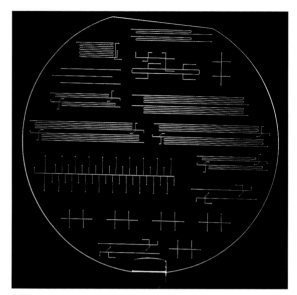

3.27a

3.27b

I find it easier to compose a photograph if I have two or more samples of the subject. The redundancy also helps evoke an experiment's reproducibility. Consider a variety of images that reveal this (3.28a–3.28f).

3.28a

3.28b

3.28c

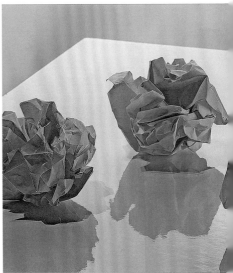

3.28d

3.28e

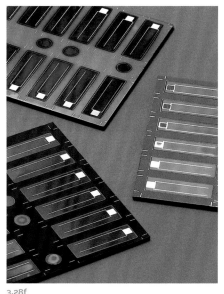
3.28f

Scale

Journals often prefer that images include scale bars, a quite literal way to show scale. I encourage you to consider other ways to show size, though, especially when communicating to nonexperts. For example, I've often seen researchers use a coin (3.29a). Perhaps taking one more step to reposition the pieces creates a slightly more interesting image (3.29b). You can sometimes use a coin to show scale and a mechanical property of fabricated material—if that is relevant to the science (3.30).

Besides the omnipresent coin, consider using other recognizable objects, too. I thought I was being clever in one image by highlighting similar reflective properties and showing a Lumina microarray against a CD (3.31). How could I have known that the CD would become obsolete and that so many of my younger students would have no clue what one was? I am confident that will not be my last mistake.

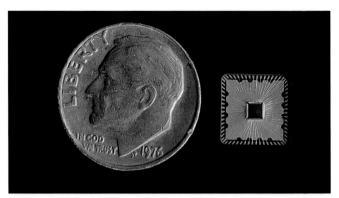

3.29a

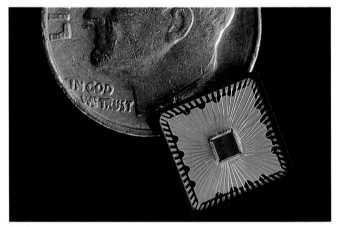

3.29b

3.30

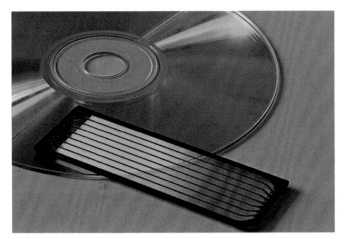

3.31

3.32

One final example is literal, with scale bars. I used a scale bar as a true measure of a wafer, incorporating it as part of the image's design (3.32).

3·33

3.34

Movement

Video is used most often to capture movement, but there are other ways as well. Video is essentially a series of still images. Creating your own still images over time can often communicate change because it is easy to see from one moment to the next. Consider images of centimeter-thick glass sandwiches encasing block copolymers, research by materials scientists Ned Thomas and Hyunjung Lee (3.33). As the solvent evaporates around the edges, the copolymers change configuration, which translates into color changes.

Another image shows the Belousov-Zhabotinsky reaction, a chemical oscillator (3.34). I was privileged to photograph the

3.35

3.36

images in the lab of biophysicist Anatol Zhabotinsky at Brandeis University. The original images were made on film. Look carefully at how the self-oscillating reactions change over time.

Another approach is to suggest movement by overlaying one or two images taken a few moments apart (3.35 and 3.36). Note that one of the images used in the overlay is more transparent than the other.

Reflect on this chapter's images made with the camera. Consider them examples of composition, background choices, and depth of field.

In conclusion, I want to share the image of an experimental small heat machine with no moving parts, from the research of mechanical engineers Evelyn Wang, Asegun Henry, and Alina LaPotin (3.37). The primary reason for the image's success is the light source. Because of the metallic nature of the material, I was lucky. I saw the image the minute I walked around my studio with diffuse sunlight coming in from the window. It was just the

right light source. I didn't plan it. But I did have to plan how to set up the image—how to hold the device in place, with only the out-of-focus carpet in the background. That planning and playing is the fun part. Give yourself that gift. Make the time with your camera and figure out how to make your images sing with light.

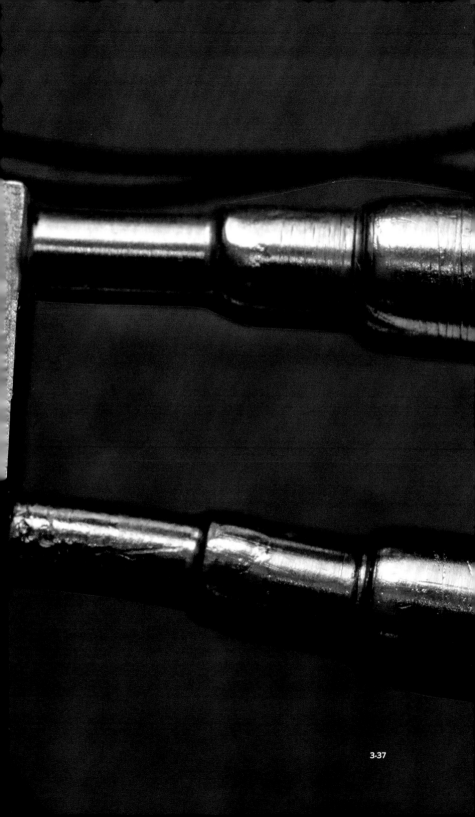

3-37

4
Microscope

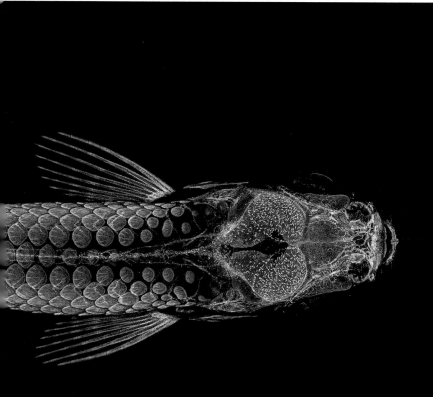

This stunning confocal zebrafish image was created with confocal microscopy by Daniel Dan Castranova, Bakary Samasa, and Brant M. Weinstein, of the Eunice Kennedy Shriver National Institute of Child Health and Human Development. Keep this image in mind throughout this chapter, and I'll discuss it at the end (4.0).

The first time I connected my camera to a microscope and looked through the camera's viewfinder was a profound experience. I am confident it was or will be the same for you. You will see things in ways you could never have imagined.

This chapter describes a photographer's approach to using a microscope. I am not a microscopy expert, but I do use the tool to reveal a point of view that cannot be depicted with a camera alone.

When you look at your work through the ocular of a microscope, it is not the same as seeing what your attached camera is seeing. The camera is attached to an adapter that contains an enlarging lens, which results in a different framing from what you see in the ocular. You will also find that you will not have the

control you typically have with camera and lens. When photographing with a microscope, you will find the following:

- Little choice over the positioning of your camera and the object you are photographing
- Minimal control over depth of field
- Only some control over the quality of lighting
- Little need to select backgrounds (for the most part)
- Only some ability to make choices in composition

Let's talk about an important technical issue before looking at some images. While making pictures with a microscope, it is very important not to focus your photographs through an ocular. *Always focus through the camera*. The microscopy sales folks will tell you it's not necessary, but that is not the case. Trust me. I encourage you, as in chapter 3, to use software to view the image on a computer screen. This makes it much easier to focus and compose.

Dissecting or Macro Microscopy

I also want to encourage you to consider using a dissecting (or stereo) microscope in your lab. You might think that if your work is about small details, you do not need one. Maybe your research focuses on material that you believe requires a compound scope or a scanning electron microscope (SEM) or transmission electron microscope (TEM). But as I travel around campus, I've come to the following conclusion: it is an error to not include photographs showing *context* in your work, meaning *where* the detail is in the larger scheme of things. The context helps you communicate your science.

Let's start by considering an image from a colored SEM that I made a while back (4.1a). It is a detail of an IBM 7094 computer from the mid-1960s. Each doughnut-shaped magnet "remembers" 1 bit. The computer had 32 kilobytes of memory, arranged in 36-bit words. This detail would be more communicative if we

4.1a

4.1b

could see it at different scales. To do this, I used a scanner to show the entire core (4.1b). In another, using my stereo microscope, I got a little closer to give viewers a better sense of what the material looks like (4.1c).

Consider a series I made of the mechanical engineer Nick Fang's metamaterial. I first made the image using a stereo microscope (4.2a). I made two additional images with a compound microscope using two magnifications (4.2b and 4.2c). The image with the second magnification has a very narrow depth of field, which in this case, is informational. The viewer understands the three-dimensional structure *because* part of the image is not in focus.

4.1c

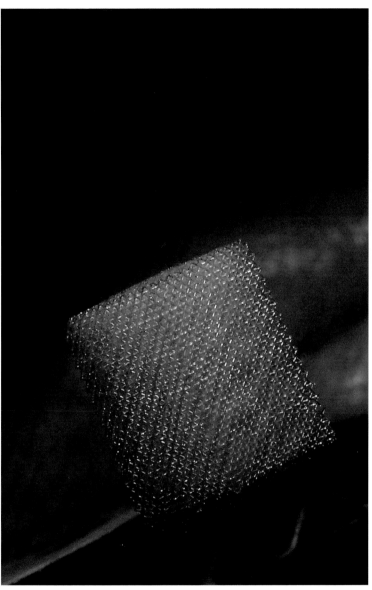
4.2a

4.2b

I remember the first time I made a photograph using a microscope. It was in the biologist Gerry Fink's lab about thirty years ago, when I arrived at MIT's Edgerton Center. With a dissecting microscope, I played with the light transmitted from below the sample. The scope I was using was old and required the user to move a mirror from below the sample to reflect the light from

4.2c

beneath the stage. Small changes in the direction of the light affected the final photographs, just as we have already seen in other examples. Compare the yeast colony images and notice how different they appear even though both have identical compositions (4.3a and 4.3b).

4.3a

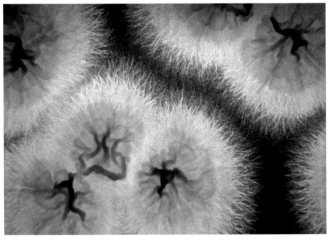

4.3b

COMPOSITION

In a way, I was lucky to have started with a stereo microscope. I was able to make decisions about composition that I later discovered would have less utility as I went to more magnified images using a compound microscope. Consider two images

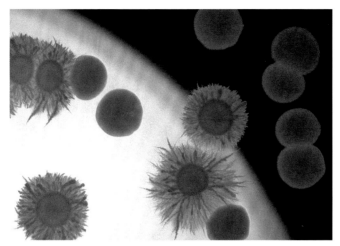

4.4a

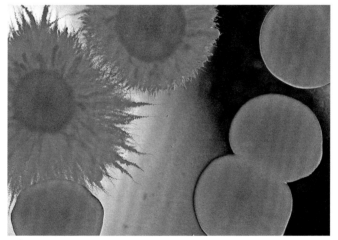

4.4b

of different morphologies of yeast colonies. In my opinion, the first is a bit too dramatic (4.4a). The viewer is drawn to the light source in the background. In the second, the more zoomed-in image, the viewer sees the differences in shapes (4.4b).

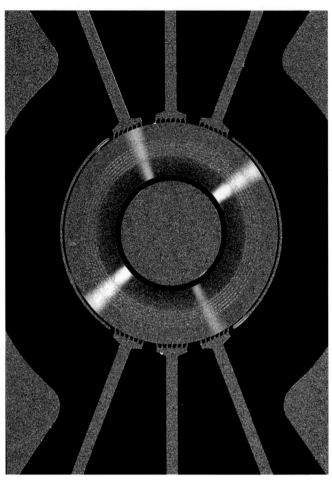

4.5a

Experimenting with different compositions can help keep the focus on what exactly you are trying to show. For the microfabricated device made by electrical and computer engineer Reza Ghodssi, when using reflected light, each image tells a slightly different story. One is saying the device is symmetrical

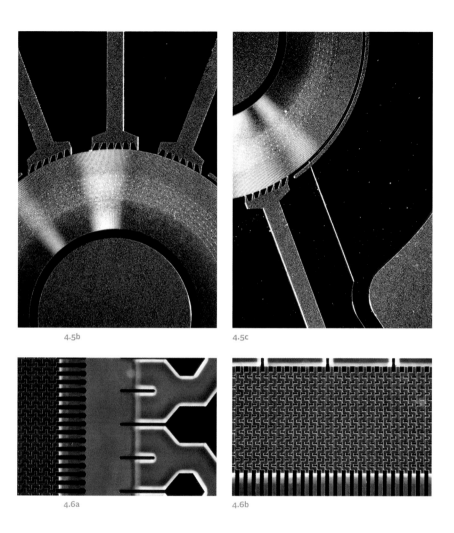

4.5b

4.5c

4.6a

4.6b

(4.5a). Two more bring the eye to more detail (4.5b), and then with increasing magnification (4.5c).

I did the same for details of a microreactor from Klavs Jensen's lab (4.6a and 4.6b). Try moving your sample around with each magnification, just as I did.

4.7a 4.7b

When the bioengineer and physicist Steve Quake sent me his microfabricated cell sorters to photograph, I wasn't sure where to start (4.7a). I finally decided to take one, put it on the stage of the dissecting microscope, and compose a cover for the journal *Science* (4.7b).

4.8

Sometimes deciding on a composition is straightforward, as was the case for a microreactor created by the chemical engineer Brian Yen in Klavs Jensen's lab (4.8). There was no need to overthink the composition for ordinary clear water droplets on a transparent surface in Mathias Kolle's lab that produce brilliant colors without the addition of inks or dyes (4.9).

4.10a

4.10b

Sometimes, though, it is not so straightforward. Consider an image of another microreactor. Note how I composed the image asymmetrically (4.10a). Then consider another one, taken with a camera, with a centered subject and obviously different lighting conditions (4.10b). I think the first one works better,

4.11

compositionally. By the way—do you see that the bottom of the second image is slightly out of focus? It was the best I could do. I was shooting at f/29 because the camera wasn't directly over the sample as it was on the stereo microscope.

Another idea for composition is to include a small element of the material in the background of the image. But don't go overboard. Include just enough to give a sense of what the edge looks like. This can add a subtle component. Years ago, I photographed one of the first applications of an electronic ink concept originally conceived at Xerox PARC (4.11). Joe Jacobson developed it further, along with his students J. D. Albert and Barrett Comiskey. Today, "e-ink" technology is found in many e-book readers. I remember Joe questioning me about why I put the sample on a slant and, worse, why in the world I included the copper background. I don't remember what my response was, but I do remember not having the confidence to tell him that, in my opinion, it worked better, compositionally, than what he had in mind. I am delighted that years later, those sorts of explanations are no longer necessary. I continue gaining the trust of most researchers. I just wish it didn't take so long.

4.12a

4.12b

Let's look at one more example of composition, with individual pieces of artificial muscle fabricated by biomedical engineer Seyed Mirvakili. My first notion was to randomly place the pieces (4.12a). But I later realized the image was confusing. Instead, it worked better to place each separate image in a particular order, to tell the chronological story of the fabrication process (4.12b).

4.13a

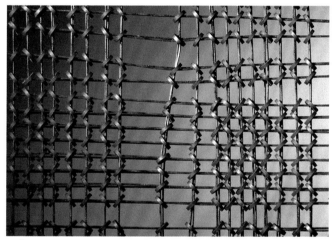

4.13b

LIGHT

Let's look again at images of an object, a computer's memory core, you've seen already. One uses transmitted light (4.13a), and another uses reflected light (4.13b). The images are very different from each other.

4.14a

4.14b

Now consider two images of three-dimensional microstructures by Rebecca Jackman and George Whitesides, again with transmitted light (4.14a) and reflected light (4.14b). The image with reflected light emphasizes the three-dimensional property better than the image with transmitted light because we see shadows. On the other hand, that image might be too busy. It did make the cover of *Science*. What do you think?

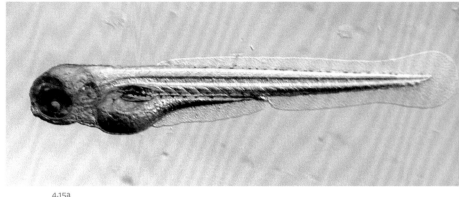

4.15a

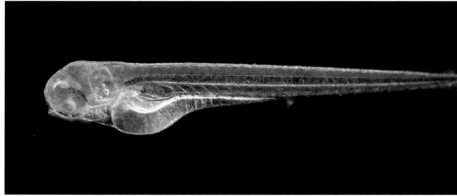

4.15b

The direction and quality of light result in different images. Look at an image made with transmitted light of the molecular biologist Nancy Hopkin's four-day-old zebrafish (4.15a). I changed the light source with the scope's built-in patch stop, which covers the central part of the light and almost imitates darkfield microscopy (4.15b). After reviewing the two images, my first thought was that the details were clearer in the second image with a dark background. Years later, reconsidering images for this handbook, I realized that what appeared to be an outline of the fish in the first image was not present in the second. Perhaps the second is not the better image after all.

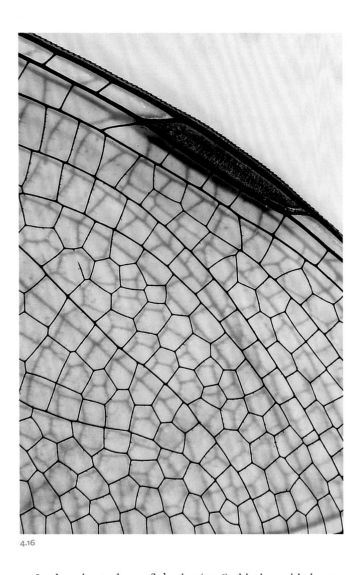

4.16

Look again at a dragonfly's wing (4.16), this time with the stereo microscope. The reflected light casts shadows of the amazingly intricate structure. I think the shadows work well in this particular photograph.

4.17

4.18a 4.18b

SHOWING CHANGE

As with using a camera lens, you can take a series of images with the dissecting microscope over time. As part of a series of photographs with transmitted light, I made images of physicist Toyo Tanaka's study of acrylamide gels absorbing water (4.17).

In another example, two images demonstrate the concept of e-ink, shown earlier, too. In a detail of the letter *B*, each image shows how the microcapsules respond when addressed with a current—flipping either to the negatively charged black pigments (4.18a) or to the positively charged white pigments (4.18b).

4.19b

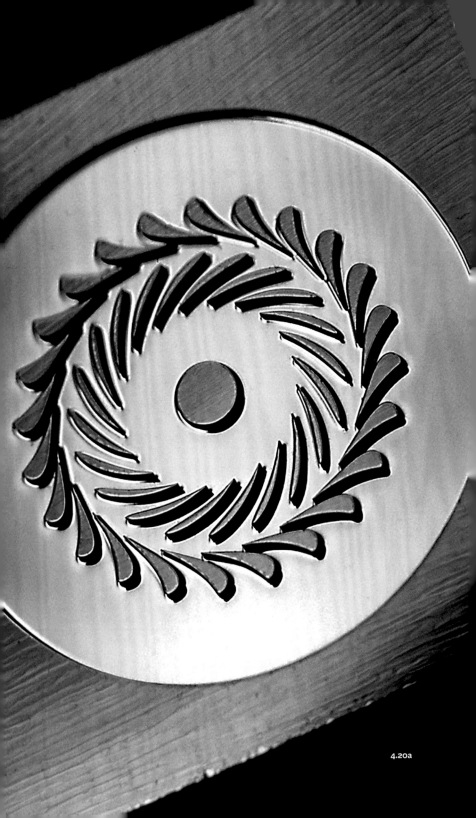

4.20a

4.20b

Compound Microscopy

When photographing engineered small devices, surface chemistry, biological research, and so on, a good compound microscope will give you the following:

- Higher magnification than the camera and stereo microscope
- Both transmitted and reflected light
- Darkfield and brightfield settings
- Nomarski interference contrast (NIC) microscopy, also known as differential interference contrast (DIC)

Surface structures are often made clearer and more communicative when using the DIC technique. This particular microscope has four objectives: 5x, 10x, 20x, and 50x. Most researchers never consider using a mere 5x magnification. You can and should! Here again, I encourage you to photograph context. Making an image that shows a particular detail in context, before being an isolated detail, is a powerful tool for communication.

For example, consider the images on the previous pages that I made with the 5x objective, using DIC (4.19a). The subject is a device from chemical engineer Chris Love's lab; it has arrays of wells for single-cell analysis. Then consider a detail of that device, also using DIC and at higher magnification (4.19b). The two magnifications tell a story.

Look at an image of a 1-centimeter-wide microrotor from aeronautical engineer Alan Epstein's lab. First, I used a camera and lens (4.20a). I then decided to see what each rotor looked like under the microscope using DIC and composed the blades in such a way that a journal accepted it for the cover (4.20b).

Another example shows an image of silicon oxide membranes from chemical engineer Klavs Jensen's lab (4.21a). With DIC, the colors indicate they are under stress (4.21b).

4.21a

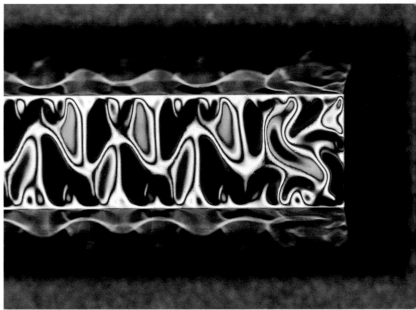

4.21b

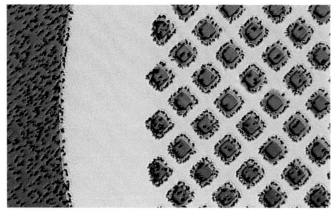

4.22a

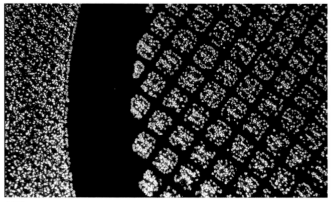

4.22b

Observing the differences when imaging with brightfield versus darkfield can turn out to be valuable. Keep in mind that darkfield is just that—dark! Therefore, it probably requires longer exposures. I encourage you to take the time. It's worth it. Consider an image of chemist Joanna Aizenberg's patterned calcite deposits under brightfield using DIC (4.22a). Then look at it under darkfield (4.22b).

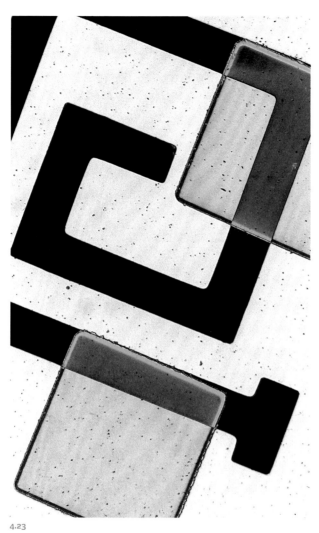

4.23

PREPARING THE SAMPLE

Chemical engineer Kathy Vaeth was working in Klavs Jensen's lab years ago with a process called chemical vapor deposition. She decided to use interesting shapes to demonstrate her control over the deposition patterns (4.23). Thinking visually certainly helped to bring attention to the research.

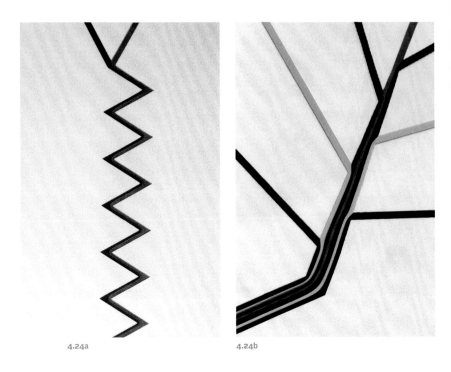

4.24a 4.24b

I was delighted when chemists Paul Kenis and Rustem Ismagilov agreed with my thinking and created a new sample specifically to communicate their science more clearly. They first fabricated a sample of microchannels flowing with two colors of ink (4.24a). The scientifically relevant finding was that the inks did not blend together and stayed in a "laminar flow." To communicate this finding, I decided to make seven channels, with seven distinct colors of ink flowing into one channel. In this final image, we are showing that all the colors are flowing in distinct layers. The final image made the cover of *Science* (4.24b).

Previously we saw images of a yeast colony (4.25), but creating those has an even longer story behind it. Years ago, Julia Köhler, in Gerry Fink's biology lab, was growing a mutant fungus

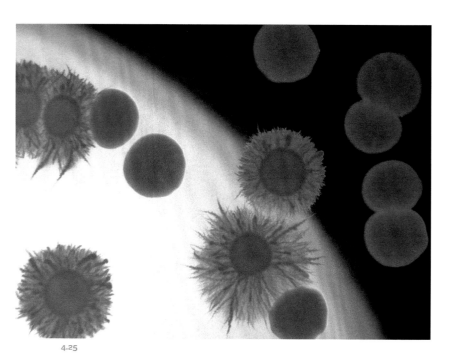

4.25

and its wild-type (or "natural") parent. The scientifically interesting point of her research was that the different genetics of the two strains led to different shapes as the fungi grew. The actual experiment was conducted with the strains in separate petri dishes. But two separate photos of the different fungus shapes didn't immediately communicate the science. Instead, I wanted to show the reader the differences in one image and one petri dish, not two. Using one petri dish implied much more easily that there was only one variable that could lead to the different shapes—the genetics of the fungus. Not all researchers would have agreed to go along with the idea, and I was grateful to Julia for her confidence to think visually.

4.26a

Preparing the sample so that the viewer can immediately make a comparison across images, or what I call showing "the other," helps again to communicate the point. Another example of this is an image that demonstrates the control of self-assembly of gold colloids in a specific area on a surface (4.26a,

4.26b

right side of image). The left side of the image appears different, as the colloids are not assembling. Compare this image to another in which we see only the section of the surface that is self-assembled (4.26b). I think it's a less interesting photograph.

FOCUS

As with cameras, it's difficult to have all planes in focus in optical microscopy. You are going to have to make choices. In creating one image, I focused on a magnet (4.27a). In another, I focused on the wires in the back (4.27b). You can try stacking, as discussed in the camera section, but the process might be excruciating. You can also try a trick on the compound microscope. Look at a before image (4.28a) and an after image (4.28b). What changed? I adjusted the aperture setting on the microscope, similar to decreasing the size of the aperture (stopping down) for the camera lens (as in chapter 3), so more appears to be in focus.

Another example is a more recent image for which focus was important. The image is of a sensor patch that monitors a person's health when a wearer is perspiring (4.29). The work is from the mechanical engineers Jeehwan Kim and Hanwool Yeon.

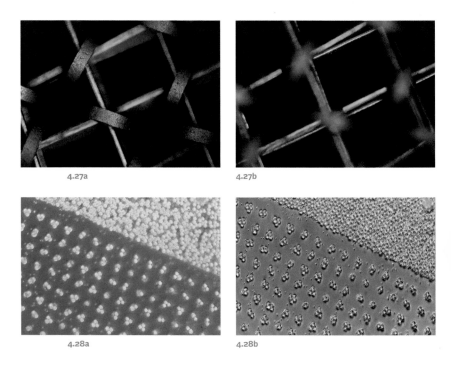

4.27a

4.27b

4.28a

4.28b

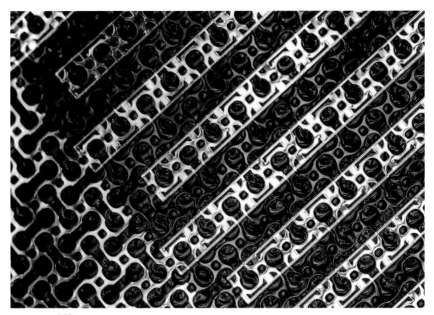

4.29

A NOTE ON BACKGROUNDS AND LIGHTING

I mentioned at the beginning of the chapter that you will have little need to consider adding a background in microscopy. There is always the exception. Consider the image I made of engineer Ken Szajda's syringe embedded with microchips using a 5x objective (4.30a). It's not a very impressive image. I realized the lighting from the microscope was not helping with this particular material, so I used exterior lighting from a monopoint lamp. I also decided to see how the syringe would photograph with a new background. The resulting image is so much clearer (4.30b). The background was a box of Kodachrome 25 film. (Am I showing my age again?)

4.30a

4.30b

Scanning Electron and Confocal Microscopy

Both confocal and SEM microscopy are highly specialized. The equipment is expensive, and a great deal of training is involved before using them. I include only a few images here, especially since these microscopes are not a major part of my toolbox.

I am often surprised when so many young researchers go right to the scanning electron microscope, even if the details of the

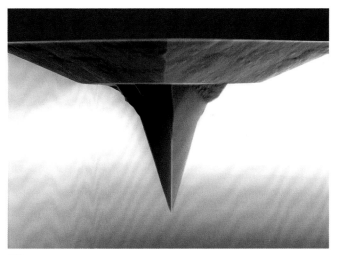

4.31

research are in the optical range. It's true that using an SEM gives amazingly sharp images, so using one is pretty seductive. But I want to encourage you to also include optical images as well. Why? First, images taken with an optical microscope will have a higher resolution. Therefore, zooming in on the subject captured in your camera will not be a challenge. Second, finding time on an SEM is often not a trivial task. Usually, a good SEM lives in a special area on your campus, and operating one takes an expert who might also be limited with time.

When I work with SEM, I always collaborate with an expert. I usually act as an art director, asking for a particular point of view or a change in angle. Often, I color the images for better communication, always indicating when I have. Here are just a few original grayscale images that I was involved with over the years. I will show the colored versions in chapter 6.

Chemical engineer Chris Love helped me to create this image of an atomic force microscope (AFM) tip (4.31). AFMs are used to image objects at the nanometer scale, much smaller than any

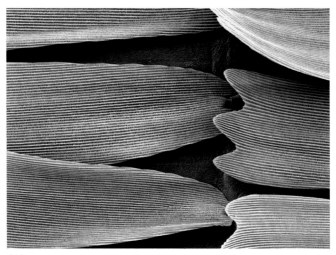

4.32

optical microscope can see. Look at the detail of a butterfly wing (4.32). Or an SEM image from John Hart's lab made by combining a series of smaller SEMs with software developed by Michael Cohen when he was at Microsoft (4.33). You'll see some of these images again in a different form in chapter 6.

You saw the opening of this chapter made with a confocal microscope, and I am sure you were drawn to the image as I was. Dan Castranova and colleagues used the complex confocal fluorescent process, which *optically* sections the sample and then stacks images together to form a three-dimensional model. The image is striking, and new information resulted from the process. They discovered that the zebrafish possesses certain anatomy that is comparable to mammals.

4.33

Special Case

I thought I would end this chapter with an image that genuinely inspired me to pay more attention to the potential of focus stacking in microscopy. I had no idea of the large amateur community that was passionate about using stacking to make stunning images of nature. I found this image in the Nikon Small World competition and just had to reach out to the photographer, Dr. Andrew Mark Posselt. Andy was kind enough to give me time in his busy surgical practice to answer some questions. But first, look at his image of a hind leg of a male frog-legged beetle (*Sagra buqueti*) (4.34a). The stacked image was made from two hundred separate images, each one taken 50 microns apart at different focal planes. The final stacking was made with Zerene software.

Andy explained to me that making the image was only part of the process. Cleaning the sample was also tedious and time-consuming. He was generous to label this cropped image of his DIY setup (4.34b). The labels show (1) tube lens (used

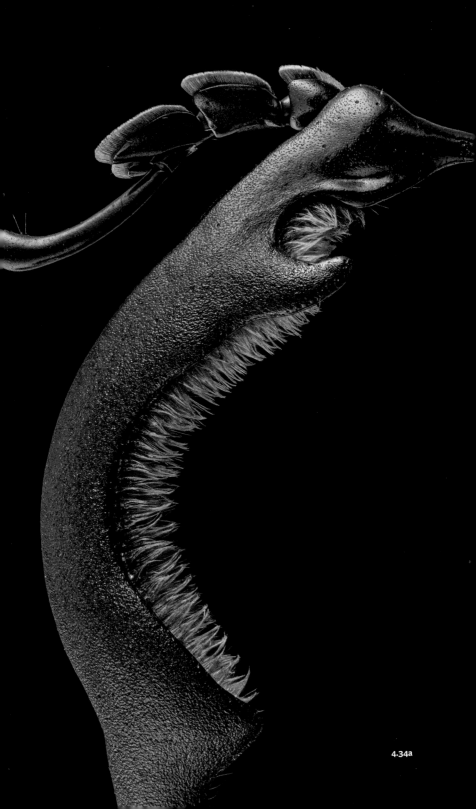

4.34a

4.34b

with infinity objectives only); (2) objective; (3) light diffuser; (4) flashes—used to minimize the effect of vibrations, which are notorious for ruining images at high magnifications; and (5) motor for performing stacking.

The silver box is the controller that connects with the iPhone for programming the length and number of steps. The size of steps depends on magnification, numerical aperture (na) (for objectives), and aperture. Smaller apertures are generally not used due to diffraction effects. For magnifications greater than 4x–5x, it is usually better to use objectives, as they generally have a larger aperture (or na) than lenses. The IKEA lights are used to illuminate the object for positioning and cleaning. The black wooden board under the setup is heavy and on Sorbothane pads to minimize vibrations.

MICROSCOPE 175

5
Putting It Together

Many years ago, when photography became more than an avocation for me, I took a weekend course with Jerry Uelsmann, the renowned photographer who created remarkable black-and-white images by combining pieces of photographs into one final, mostly surreal image. His process, developed before the advent of photography software, was excruciatingly detailed and cumbersome. Try to imagine the plan. He had a series of enlargers lined up in his darkroom, each with a negative with content that would eventually wind up in a final image. He would then take the easel with the photographic paper down the line and expose the paper for each negative, *in the right spot on the paper and the right exposure!* He repeated this process until the final image was made with all the pieces in place. His images are stunning. Look him up online and treat yourself to a few images to savor and study.

With digital photography, that complicated process is made easier. I have taken up a similar approach in order to create images that communicate science and engineering concepts. I encourage you to try the same. This chapter teaches you to create photo illustrations, in which pieces of photographs are digi-

tally put together (5.0). Sometimes I create these images to tell a visual story about structure or process, and other times to create a metaphor to show an idea that cannot be photographed. All these images appeared on journal covers, on the MIT website, or in slide presentations.

I've separated the images into three categories: structure, structure plus, and metaphor. For structure, the purpose is to show a device or process by combining images that are not easily captured (or impossible) at the same time. Structure plus images are photographs to which an element was added that elevates the aesthetics and better communicates the concept or in which additional elements are organized for clarification. Finally, metaphor is exactly that: images that explain a structure or process for which creating a photograph is just not possible. One might argue that any visual representation can be considered a metaphor, but here I am using pieces of a photograph to explain a structure or concept.

5.1

5.2

Structure

For Alice White's work years ago at Lucent (formally Bell Labs), I made a series of microscopic images of her optical chip and juxtaposed each image so that we could see the full device (5.1). Notice that I kept a space between the images to suggest my process. I did the same for Matthew Hancock's study of sediment sorting under standing water waves in a water chamber (5.2). This time, I overlapped the images to suggest, once again, the photographic process, which I thought would interest the viewer.

Consider the final image of double-sided tape created for use in surgery from the engineer Xuanhe Zhao's lab (5.3a). I first received the material in a petri dish and placed it on a black background to see how it would look (5.3b). For the next image, I started incorporating various tools that suggest surgery utility (5.3c). Closer to what I was looking for, my shiny black iPad screen served as the background (5.3d). Christine Daniloff digitally added a few layers to see whether filling more space would

5.3a

5.3b

5.3d

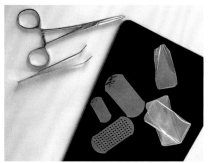
5.3e

5.3c

work. We then digitally rearranged the pieces and digitally colored the larger background (5.3e). For another final image, you see a petri dish containing two membranes on the right and two on the left (5.4a). The image is of a "gas gating" mechanism (the left membranes are coated with gold), which could provide a way of continuously removing carbon dioxide from a stream of waste gases. The work is from chemical engineer Alan Hatton's lab; Yayuan Liu supplied me with the material. I first placed the dish on a green background—too crazy (5.4b)! I then tried a windowsill (5.4c). Zooming in on that image still didn't cut it (5.4d). Note in the final image (5.4a) how I changed the lighting to add a shadow to make a more interesting image. Most important, I digitally inserted the left circular pieces from another image with better lighting.

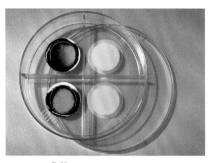
5.4a

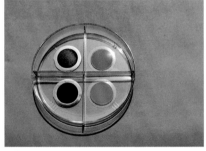
5.4b

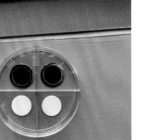
5.4c

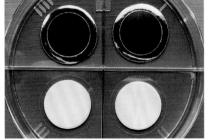
5.4d

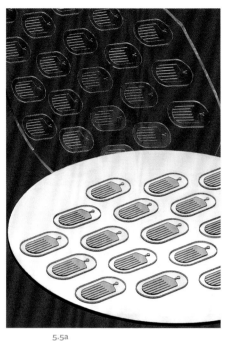

5.5a

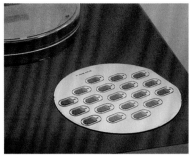

5.5b

5.5c

Look again at the image used for the chapter opener (5.5a), in which I combined two other photographs (5.5b and 5.5c). This is research by medical scientists Suman Bose and Daniel Anderson. The clear material, made by imprinting with the wafer below it, is used to create flexible protective devices to encapsulate therapeutic cells. The photographic challenge was to get the best lighting for both very different pieces of material. The solution was to independently photograph the two separately and then put them together digitally.

5.6

Structure Plus

In 1997, I made one of my first attempts to add digitally to an image to better depict an invisible process. In this case, I added an illustration—a laser beam that I made in Photoshop (5.6). The apparatus was part of the work by physical chemist John Rogers and physicist Keith Nelson on an optical system to be used to characterize material.

Another final image depicts mechanical engineer Svetlana Boriskina's research, developing a new kind of sustainable textile from polyethylene fibers that may help humans adapt to and combat the effects of climate change (5.7a). I first took a picture of the batch of woven material knitted by Mary Jane Schmuhl to show my starting point (5.7b). Anticipating the digital process, I stretched out the material by inserting colored cardboard in a few of the pieces and scanned each one (5.7c). I then digitally selected and removed the blue areas to be able to see the holes. I later digitally tinted the textiles and overlaid each one over a digital background for the final image.

5.7a

5.7b

5.7c

5.8a

5.8b

Working with Polina Anikeeva and others, the materials scientists Mehmet Kanik and Sirma Örgüç developed artificial muscles that could stretch more than 1,000 percent of their size and lift more than 650 times their weight: consider the final image (5.8a). To create it, I scanned the material, laying old-looking parchment-like paper over the material for the background (5.8b). Creative director Christine Daniloff did her magic by inserting a part of a stock drawing of muscle to finalize the image (5.8c).

5.8c

For another final image (5.9a), I first made a microscopic image of one of the small mini-spectrometer chips (5.9b) and digitally placed it in the background to suggest more about the structure of the chips. Note how I cropped the second image (5.9c) for the final photograph. The research was developed by materials science and engineer Juejun Hu and others.

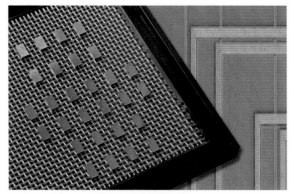
5.9a

5.9b

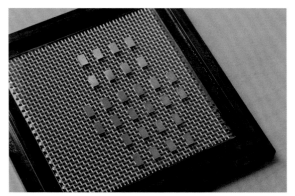
5.9c

5.10a

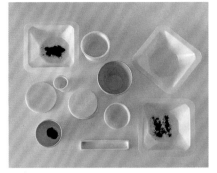
5.10b

5.10c

Zachary Hood, a materials science and engineer, asked me to come up with an image reflecting the day-to-day life of a ceramicist. Similar to the previous example, for the final image I digitally added a background to the original image (5.10a), but this time I wanted to show the perovskite structure that the materials in the containers were used to create (5.10b and 5.10c). I added drop shadows to each piece.

5.11a

5.11b

An image created for chemical engineers J. Christopher Love, Laura Crowell, and Amos Lu shows a desktop machine that can manufacture small amounts of different biopharmaceutical drugs (5.11a). Christine used all of these pieces I photographed in the lab and combined them to show the process (5.11b).

5.12a

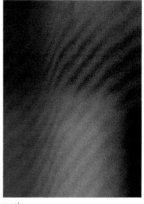

5.12b

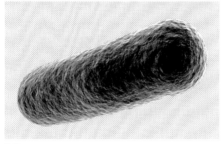

5.12c

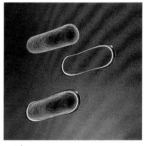

5.12d

Visual Abstraction

In an example of visual abstraction (5.12a), chemical engineers Ariel Furst and Gang Fan wanted to create a cover submission associated with their paper. In their research, they created a coating for microbes used to treat gastrointestinal disease. I first sent Ariel a background (5.12b). After a few iterations with an image of *E. coli* (5.12c), I inserted the latter and surrounded it with part of an image from another photograph I had made before. The point was to suggest the coating (5.12d). If you look

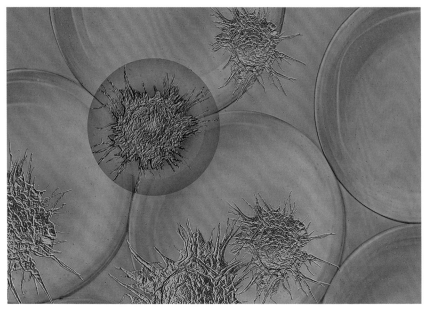

5.13a

carefully, you can see a small sparkle of light in the coating at about two o'clock. That important piece, also from another photograph, added a more realistic look. Later, I colored the coated microbes with a slightly orange tint, as Ariel suggested, to further differentiate between the coated and uncoated microbes.

Bioengineers Joshua Doloff and Omid Vegas wanted to submit a cover image that would suggest how a particular chemical alteration could help scientists extend the life span of many types of implantable medical devices by blocking the formation of scar tissue around the devices (5.13a). I used a relevant background of microscopic capsules that I had in my files (5.13b) and then purchased the rights to Dennis Kunkel's colored SEM of a macrophage. I thought that altering that macrophage with a series of filters in Photoshop would metaphorically suggest that it no longer was able to do its work of attacking the foreign body (the medical device). I composed it further, to leave room for

5.13b

the journal's logo, and added more filtered macrophages. It did make the cover.

Mechanical engineer Ken Kamrin was looking for an interesting way to depict his new and simple equation to calculate the force required to push a shovel—or any other "intruder"—through sand—look at the final image of this (5.14a). Ken previously made the point that his equations would work with all sorts of media and intruders, so I also tried toothpaste, denture adhesive, and baby diaper rash cream for other possible "media" metaphors. I found using salt to be interesting but, frankly, too interesting (5.14b). There was so much going on that it was difficult to see the point of the photograph, even with a caption. I knew I had to simplify the idea. After a little searching online, I found some great-looking sand-like material that worked in the end (5.14c).

5.14a

5.14b

5.14c

Another example: the final image for a news story describing work in astronomy (5.15a). Because I have the pleasure of working for the MIT news office along with my other responsibilities for the departments of chemical and mechanical engineering, I have the privilege of being "in" on the news stories before they are posted on the MIT website. The moment I saw the description of how astronomers were able to use a massive cluster of galaxies as an X-ray "magnifying glass" to peer back in time, an image from my files popped into my head. I did, in fact, have an image of a magnifying lens that I made for my book with George Whitesides, *No Small Matter* (5.15b). We used the image for another metaphor where George's text describes the process of how "writing with light" is used in photolithography—to create intricate patterns on computer chips. Christine added some relevant galaxies (5.15c) for the final image.

5.15a

5.15b

5.15C

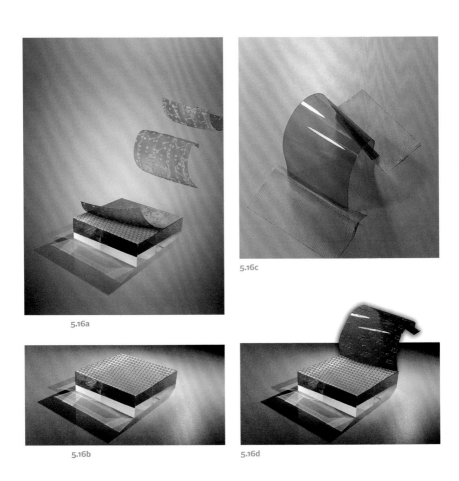

5.16a

5.16b

5.16c

5.16d

Finally, consider the final image (5.16a) for a journal cover where Nik Spencer, senior illustrator at *Nature*, brought my first few attempts at photographic pieces to a new level of sophistication (5.16b–d). We were following creative director Kelly Krause's take on how to best depict research by mechanical engineer Jeehwan Kim called remote epitaxy using graphene (5.16e).

5.16e

6
Image Integrity

6.0

The question of how far one can go to enhance, adjust, or "touch up" an image is a critical one in science, and for that reason, I've given it a separate chapter here (6.0). Unfortunately, the subject is hardly discussed during most scientists' training. *Nature* published an editorial, "Image Doctoring Must Be Halted," on June 29, 2017, stating that "the primary responsibility for image integrity lies with principal investigators." I suggest going further and placing this responsibility at the university level. As I have often mentioned, I have the privilege of working with some of the most remarkable and respected researchers in the world, and yet I have been surprised that some have given little thought to the issue of image integrity. Perhaps that's because many principal investigators no longer make the images themselves—it is a task often assigned to graduate students. The relative ease that today's software allows for revising and improving the image may, unfortunately, prevail over rigorously questioning any such changes. And although university ethics guidelines consider plagiarism unacceptable, they rarely, if ever, indicate whether image manipulation is a form of potentially dishonest scholarship. Most researchers assume that certain adjustments

are permitted in pictures, but that is not always the case. Fortunately, guidelines addressing image manipulation are finally showing up on various journals' websites.

As I hope I have made clear in this book, the very nature of making an image involves a subjective decision from the start. It takes the form of deciding what and when to photograph. Thus, it is a mistake to get bogged down with the idea that no enhancement should be permitted. You already edit the evidence by deciding what to include in the frame. Moreover, your camera might be different from mine, programmed according to the company's specifications, to capture various levels of color, for example. If we can agree that the purpose of your visuals is not only to show evidence but also to communicate that evidence, then we can permit some enhancement to help the viewer read the information, as long as we specify exactly how the image was enhanced.

In general, a good starting point, as pointed out in submission guidelines for *Cell*, is this: "Authors should make every attempt to reduce the amount of post-acquisition processing of data. Some degree of processing may be unavoidable in certain instances

and is permitted, provided that the final data accurately reflect that of the original. In the case of image processing, alterations must be applied to the entire image (e.g., brightness, contrast, color balance). In rare instances for which this is not possible (e.g., alterations to a single-color channel on a microscopy image), any alterations must be clearly stated in both the figure legend and the methods section."

The one important thread throughout all the journals' guidelines is that researchers must always indicate when any "enhancement" is applied to a photograph. Even better is that some journals now require both before and after images.

On these next pages, I'll show a few examples of image enhancements to encourage you to begin thinking about the issue of image manipulation when you start documenting the work. You have seen a few "fixes" in the previous chapters, but we never manipulated the data—that is, the science being documented. I encourage you to consider each of these next examples and question the integrity of the adjustments.

Supermassive Black Hile (SMBH) M87* photographed by the EHT team.

6.1a

Coloring

In 2019, an image of a black hole appeared on the front page of all the major newspapers in the world (6.1a). The international team of scientists announcing this remarkable feat was able to create an image using a network of telescopes known as the Event Horizon Telescope, or the EHT. In essence, smaller telescopes from eight sites around the world were synchronized to focus on the same area in a galaxy fifty-five million light-years from Earth to collect data.

Remember, this image is a translation of numbers into an image, that is, a visualization of data. There are no colors in the data. I decided to have fun and invert the image to grayscale (6.1b), coming closer to what the numbers would initially show without adding color. What do you think? Not too exciting. Astronomers have always had a better read on nonexperts than most other disciplines. They have understood the power of an image and how the right representation can bring attention and

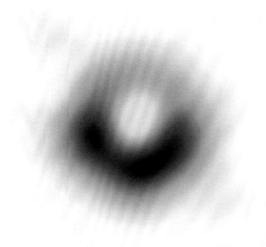

Supermassive Black Hile (SMBH) M87* photographed by the EHT team.

6.1b

IMAGE INTEGRITY

6.2

perhaps eventually lead to funding for their work. And so, to better communicate this truly remarkable project, they made the decision to color the image, using orange with various tones representing various intensities of transmissions. I, for one, am particularly blown away by the image and what it means, and I am thrilled to learn how they were able to collate all the data. In makes sense that they colored the representation as they did.

Look at another astronomical image, this one of the Carina Nebula, captured by the James Webb Space Telescope (6.2). I was privileged to be introduced to Joe DePasqale by my friend and colleague, the astronomer Alyssa Goodman. Joe and his colleagues are instrumental in translating the data this telescope collects into images. You might think this is a photograph, but as with the previous black hole image, the scene depicted in the image is actually invisible to our human eyes. Webb captures data in the infrared and not the optical range of the electromagnetic spectrum, which is where we "see" colors. As Joe says:

The decision to apply chromatic color to these filters does not imply that the information is not real. . . . It's worth noting here that the human eye is sensitive to only a very small portion of the electromagnetic spectrum containing visible light. There's no need to limit our telescopes to visible light when the universe provides an abundance of information across the entire spectrum of light! This is why NASA has pursued the creation of a variety of astrophysics facilities capable of seeing the universe across the entire electromagnetic spectrum. . . . Where we see gold shining brightly, we can clearly say that there is more molecular hydrogen in that area and begin to make inferences about the physics within a gas cloud that would cause this to happen. The decision to color these images as we do is not just for the purposes of making an attractive image, it holds astrophysical meaning as well.

You might also notice the dramatic bright eight-point stars. These, too, aren't something we can see with our own eyes; instead, they are the result of the star's light bending around the physical instrument—diffraction. Joe says, "The light waves interact not only with the support struts of the secondary mirror but also the hard edges of all eighteen hexagonal mirrors that make up Webb's primary mirror. This imparts the signature eight-pointed appearance of bright stars in Webb images."

I wonder how many nonexperts who have viewed the glorious James Webb images are aware of the decisions about the coloring process or that those stunning eight-point stars are not really there? Joe maintains a blog called *Illuminated Universe*, where he and other guest authors provide some contextual background and behind-the-scenes info on how they create the images and visualizations. Maybe the press releases should include that information up front.

6.3a

6.3b

I captured an image on Fuji film under ultraviolet light (6.3a). We see rods, measuring about 2 centimeters long, all of which have absorbed fluorescing material. My eye, however, saw some of the rods fluoresce in the orange wavelength of the spectrum, but the film did not capture that wavelength. Therefore, I dig-

itally adjusted the rods that were supposed to appear orange. In my opinion, the adjusted image (6.3b) is more "honest" than what the unadjusted film image captured. Interestingly, when I discussed this example with the editors at *Nature*, they seemed firm that my "enhancement" would not be permitted. The inability of the film to capture a particular wavelength was considered an artifact of the tool (film). I suggest we should be permitted to "fix" that artifact as long as we indicate that we are doing so. At the time, I didn't push my point of view in the conversation, and I wish I had.

The important difference between my adding color to SEM images and the astronomers' examples is that the color choices in their cases were informed by the chemical characteristics of the various areas of the image. My choices in these particular images were purely aesthetic. For example, compare the colored SEM images (6.0 and 6.4) to the grayscale SEM images in chapter 4 (4.31 and 4.32).

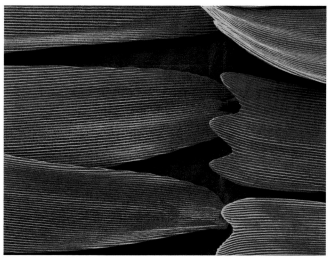

6.4

6.5a

6.5b

There is nothing new about coloring only parts of black-and-white images, but for some reason, I don't see the technique used that much in science. The original image (6.5a) was taken by mechanical engineer Stephan Rudykh, who was studying deformations in a material when force was applied. I suggested

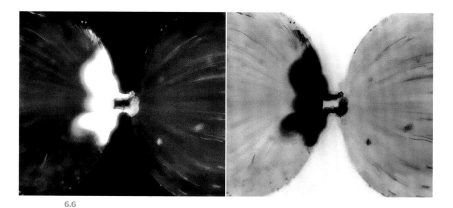

6.6

coloring just the material, and I deleted the background to simplify the image and bring attention to the material, as a means of bringing attention to an important part of the image (6.5b).

One adjustment I often suggest for grayscale images is to "invert" the images. Sometimes the details become more readable, as I believe is the case for these before and after examples of an inversion showing *E. coli*. The bacteria, from Cullen Buie's mechanical engineering lab, flow between microscopic chambers from right to left. The *E. coli* are tagged with fluorescing material. Because we are not measuring or quantifying the fluorescence but are simply showing in what direction the bacteria are moving, the inversion is permitted (6.6).

Inverting a black-and-white or color image, in general, to better communicate structure is a good idea.

Sharpening, Changing Histograms, Saturation, and Other Adjustments

For the most part, journals accept adjustments made to the entire image for better communication. For example, many images in this book have been sharpened for printing purposes.

Take an image I made on film of a device (6.7a). The fluorescent lighting in the lab added a green cast to the image of a light-emitting device. After the film was scanned, my digital adjustment altered the color to what my eyes saw (or more specifically, how my brain was compensating for the green cast) (6.7b). If I had made this image with my digital camera and first performed a manual "white balance," the color adjustment would probably not have been needed. In any event, first and foremost, no matter the intent, whenever an image is colored or color adjusted, that information must always be indicated—somewhere near the image—not on another page, where the reader has to dig deep to find out what's going on.

Changing the histogram in software like Photoshop increases contrast and often helps to better communicate the data. Consider an old gel run created a while ago (6.8a), when runs were

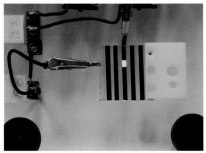
6.7a
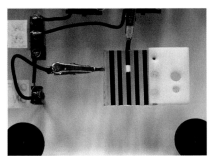
6.7b

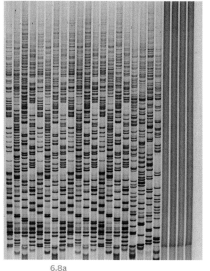 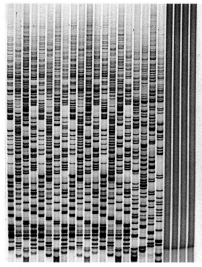

6.8a 6.8b

still captured on film. I then adjusted the histogram, increasing contrast (6.8b). I made the adjustment to the whole image, and the journal accepted it.

More food for thought from *Nature*'s guidelines:

- Processing (such as changing brightness and contrast) is appropriate only when it is applied equally across the entire image and is applied equally to controls. Contrast should not be adjusted so that data disappear. Excessive manipulations, such as processing to emphasize one region in the image at the expense of others (for example, through the use of a biased choice of threshold settings), is inappropriate, as is emphasizing experimental data relative to the control.
- The use of touch-up tools, such as cloning and healing tools in Photoshop, or any feature that deliberately obscures manipulations, is unacceptable.

Other Adjustments to Think About

For the images in this section, one might argue with my decision about making the various adjustments. Keep in mind, though, that I always indicate when an adjustment is made.

Civil engineer Benedetto Marelli and colleagues fabricated these Velcro-like food sensors to sample food for signs of spoilage (6.9a). To create a different image, I adjusted the exposure on just the sensors (6.9b).

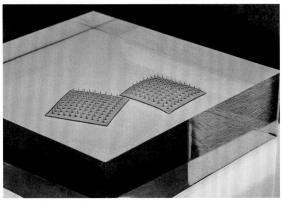

6.9a

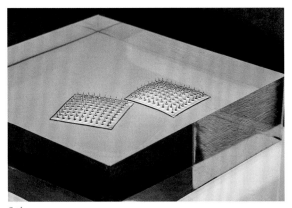

6.9b

6.10a　　　　　　　　　　　6.10b

Biologists Dan Ehrlich and Paul Matsudaira were working on an all-electronic DNA array sensor. Under the stereo microscope, we see an artifact of the imaging process (not of the fabrication of the device)—a reflection of the lens on the wafer (6.10a). I digitally removed the reflection (6.10b).

Another example is a picture I originally made of a yeast colony growing in a petri dish, from Gerry Fink's lab (6.11a). Because I wanted the viewer to see the stunning shape of the colony, I digitally deleted the petri dish (6.11b). The data in the image—the information we must keep intact—is the morphology of the colony. By deleting the dish, I am not adjusting the data. I am simply removing the part of the image that, in my opinion, is unnecessary or distracting. *Science* did permit this adjustment for the cover.

6.11a 6.11b

6.12a 6.12b

An image of some fascinating Proteus colonies growing in a petri dish is an image I made for the book *On the Surface of Things* (6.12a). Note how the agar is cracking in a few places. Because the purpose of the image was to show how the colonies grow, I digitally deleted the distracting cracks in a book for the public (6.12b). This would not be permitted for a journal article

6.13a 6.13b

submission, but perhaps for a cover shot, as long as I indicated that I altered the image.

In another image the setup was mishandled, and the gel run became slanted (6.13a). A suggestion was made to digitally "unslant" the image (6.13b). I think we will all agree that this is an over-the-top adjustment and would never be permitted in a journal.

When John Hart was a graduate student in mechanical engineering, we discussed using a scanning electron microscope for samples larger than the instrument's field of view. SEMs, unlike optical microscopes, create images with amazing depth of field, surface contrast, and clarity. For those reasons, SEM is the imaging method of choice for many investigators who work with materials with dimensions smaller than the wavelength of light. However, because SEMs are used for the most part to reveal these small features, a microscopist who uses an SEM to examine a larger structure cannot get the entire sample into the field of view. Coincidentally, I had just visited Michael Cohen, who, at the time, was a senior researcher at Microsoft Research. (Michael is now director of computational photography at Meta.) Michael showed me one application being developed that

6.14a

6.14b

included a "stitching" feature to enable amateur photographers to seamlessly and easily stitch together several images. We used it to create the final montage of the aligned carbon nanotubes grown on a silicon wafer in a "Seed of Life" pattern (6.14a). Creating montages is no longer new and is used in important research. However, here is the question to think about. Was I permitted to digitally "clean" the image this way (6.14b)?

A Special Case

Engineer and oceanographer Derya Akkaynak showed me her remarkable image enhancement software, called Sea-thru, specifically used for underwater photography. Let's first look at two examples. One was taken by Derya on a small island off the coast of Papua New Guinea (6.15a). The software then enhanced the image (6.15b).

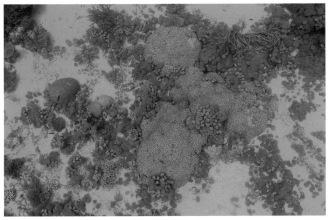

6.15a

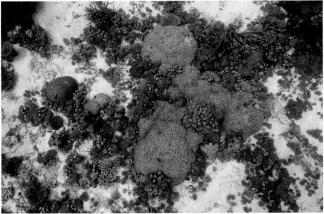

6.15b

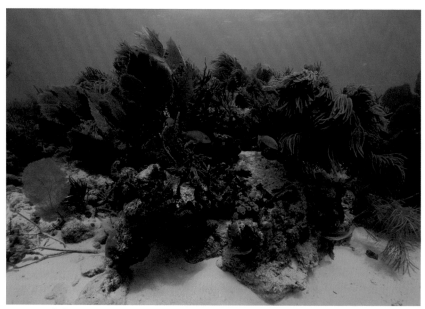

6.16a

In another example, one image was made by Tom Shlesinger in the Florida Keys (6.16a). The software then enhanced that image (6.16b). Remarkable!

I asked Derya to explain how the software works. She says: "The software is different from simple filtering, white balancing, changing histograms, or saturation adjustments. The physics-based part is important because this means the algorithm follows a physical model of how light attenuates in the water. . . . The conditions under which Sea-thru works [are] completely explained by physics, and therefore, within those conditions, its results are objective and repeatable."

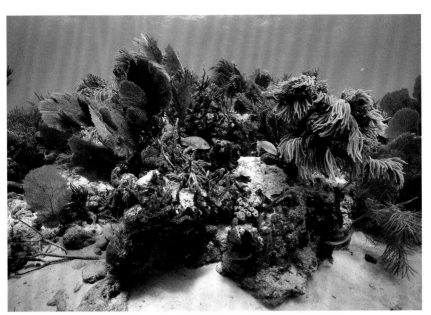

6.16b

I found this fascinating and wonder where else this sort of enhancement might be used. And now, for the final question—is this enhancement permitted? I have my own thoughts. What do you think?

Submitting for Publication

It's important for you to review each journal's submission guidelines. This short section addresses only photographic submissions to journals.

Image File Format and Size

After looking at various journals, I was surprised at how varied they all were in file requirements. Most require TIFF (tagged image file format) or PNG files (tagged image file format). Some accept PSD (Photoshop document) for a cover submission because the image can be easily edited to add logos and other information. Some journals do not require high-resolution files for the first submission. After the article is accepted, the journal staff will request images to be formatted at 300 dpi (dots per inch). Most ask for RBG color mode, except for a few cover submission guidelines that specify CMYK. Check for all of the above when you are looking to submit.

Cover Submission

Before you even think about a photographic cover submission, take a hard look at how the cover is formatted. Is the cover a full bleed? Does the image fill the entire space? Does the image appear in a circle, square, or rectangle? Where do the logo and other cover text go?

The journals are more open to adjustments for cover submissions since they are considered "art" and not scientific documentation.

So there you have it. As all the books in the Visual Elements series, this edition is meant to give you the confidence to create beautiful and informative images of your research. I hope these pages on photography have raised your awareness of all the possibilities to investigate. Producing a visual that people will *want* to look at is the first step in communication. Moreover, the next time you see a photograph in a journal or even a magazine, stay with it for a moment and see what you think. Is it a good image? How was it lit? Do you see different levels of focus? Would you have done something differently?

Gratitude

None of these handbooks would have been possible without the hundreds of remarkable students and faculty at MIT and other campuses whom I have had the privilege of working with. The best part of my professional life is that every conversation brings yet another piece of fascinating science into my life. I am grateful to them all.

My gratitude also goes to Joe Calamia, my editor at University of Chicago Press. He has kept me laughing, calm, and on time. Not bad, wouldn't you say? And my deepest thanks go to Isaac Tobin, whose talent met the challenges of designing a small handbook with precision and intelligence.

And most of all, my love and gratitude go to my extraordinary family and to my dearest friends. All know who they are.